MODERN AND CONTEMPORARY PRINTS

MODERN AND CONTEMPORARY PRINTS

A PRACTICAL GUIDE TO COLLECTING

PHOEBE PHILLIPS
TOM ROBB

ANTIQUE COLLECTORS' CLUB

ISBN 1 85149 458 8

British Library Cataloguing-in-Publication Data
A catalogue record for this book is available from the British Library

Printed in China
for the Antique Collectors' Club Ltd., Woodbridge, Suffolk

ANTIQUE COLLECTORS' CLUB
Website: www.antique-acc.com

Sandy Lane, Old Martlesham, Woodbridge, Suffolk IP12 4SD UK
Tel 01394 389950 Fax 01394 389999
Email: sales@antique-acc.com
Eastworks, 116 Pleasant Street - Suite ≠60B, Easthampton, MA 01027, USA
Tel: 413 529 0861 Fax: 413 529 0862
Email: info@antiquecc.com

Front Cover. Tom Robb: HANDING-IN DAY, *monoprint*
Back Cover. Brian Rice: NOVEMBER, *screenprint; Sally Scott:* TAMARISK AND SHADOW, *stone lithograph*
Frontispiece. Brian Rice: MIZZMAZE, *screenprint*
Opposite. Jane Levenson: THE COCKEREL, *lithograph*
Overleaf. Edward Bawden: AQUILEGIA, *linocut*

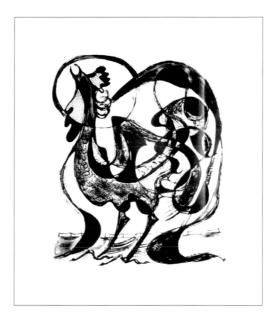

With thanks to all the artists, galleries, publishers, dealers, auction houses, friends and colleagues, far too many to list here, who have given their time and their enthusiasm to help bring contemporary original prints to a wider audience.

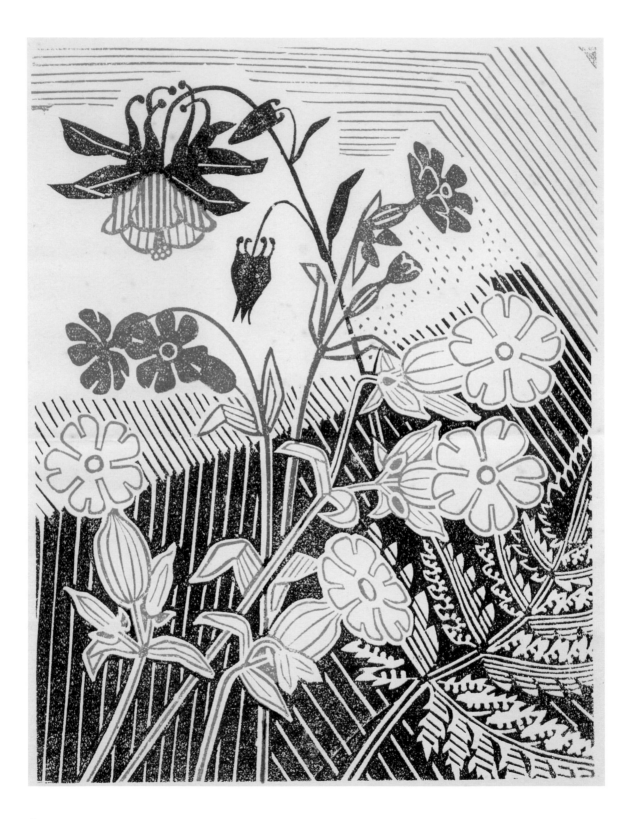

ABOUT THIS BOOK

Art is now part of everyday life. Museums and galleries are potent crowd-pullers, teeming with families of children and grandparents. Artists, students, collectors and just plain wanderers – they are all there, for enjoyment and delight as well as instruction and education.

How to bring this enthusiasm into the home, though, is a continuing story. Books and catalogues, posters and exhibitions, postcards and decorative objects all reflect cultural trends. At the same time our fascination with style and image demands we show off our own more personal taste with well-chosen and appropriately-framed artwork.

Galleries, auctions and a new phenomenon, Art Fairs, are all showing an increase in visitors and in sales, especially at the more affordable level. Now a supermarket is planning a selection of original prints to satisfy a growing art market.

But there is nothing worse for the enthusiastic purchaser than to find that what you have bought is not what you intended to take home; a photographic reproduction might be just what was wanted, but not if you imagined you were acquiring an original print.

And when screenprinting can be used for mugs or T-shirts, what is the difference when it is called a limited edition screenprint or a serigraph?

Printmaking has changed in the last decade, along with most technical processes. Computer graphics have created an entire new world.

At the same time, some artists are moving back to the traditional forms of printmaking such as woodcut, just because of their long-established and still unique qualities.

Today, more than ever, accurate information and guidance is needed, to help guard against both major and minor pitfalls so that everyone can buy with knowledge as well as enthusiasm.

This book is designed to put essential expertise from a wide range of consultants into clear language. and also to point out some of the confusing references which even the most experienced collector might find bewildering as terminology changes – monotypes/monoprints, proofs/states, and so on.

A substantial PART ONE starts with what to consider before any purchase, where to look, and what qualities to look for and to avoid. We have included a checklist of information which should be available to any purchaser, no matter how modest or well funded. The essential vocabulary of words used constantly in the trade and by critics is the heart of the book, so that jargon and terminology can be clearly understood.

Once you start to think about buying, you'll find all sorts of hints and tips from PART TWO, Starting to Collect. And when you bring the prints home, PART THREE deals with care and conservation, along with information on handling and framing to make the most of every purchase and keep prints in the best possible condition. PART FOUR offers a précis of the tech-

niques of printmaking, both traditional and modern. We look at paper and ink, followed by the three major divisions, relief, intaglio and planographic. A brief history of each process leads to a clear description of how those print are made, with advice on what to look for, and what to avoid.

Digital technology is the latest to be adapted for printmaking; we have included new ideas which may be partly or wholly computer generated.

PART FIVE includes a necessarily limited and personal selection of a few artists who were interested in the printmaking medium, and some of the printers and publishers who made and continue to make their work possible. This is followed by reference lists of books, sources, and organisations which may be useful as you want to do and learn more.

The illustrations used throughout the book are intended to reflect points raised in the text and are based on appropriate images by some famous and many not-so-famous artists. For the history of major artists, prints and printmaking since 1900, see the extensive reading lists at the end of the book.

The marketplace is always an adventure; by helping to prevent mistakes, to strengthen understanding and encourage the joy of selecting carefully and buying successfully, this guide will have achieved our aim.

Phoebe Phillips
Tom Robb

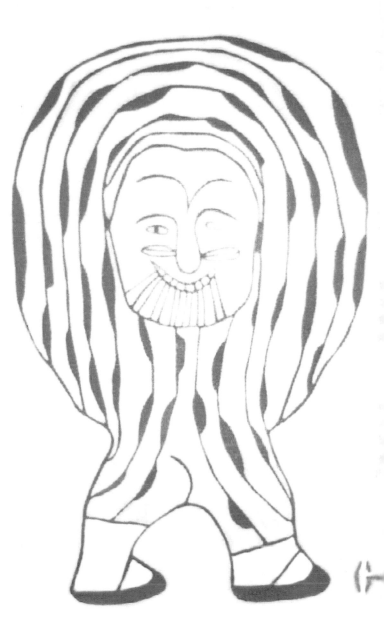

Irene Avaalaaqiaq: TIRED TATTOO LADY, *woodcut*
Prints, especially woodcuts with their strong lines and simplified images, can have a robust sense of humour.

PART ONE:

ESSENTIAL INFORMATION

WHAT IS AN ORIGINAL PRINT?

The traditional mediums of pencil, pen and ink, watercolour, oil, chalk and pastel are exactly as they describe themselves – tools for the artist to put ideas directly on to paper or canvas. But a print can mean anything from a snapshot or a teenager's magazine poster to a Warhol silkscreen or a Matisse lithograph. Today it can also encompass such mixed media artworks as a woodcut with relief, hand-painting, collage and drawing on oxidised lead foil; it is no wonder that the viewer is bemused.

To start with the most basic terminology, a print is any work using techniques which allow the image to be repeated as often as wanted. However, in the contemporary art world there is a fundamental division between a print and an *original* print.

A print is a photographic reproduction, an image which already exists in another medium. In the past there were many fine craftsmen whose job it was to turn a painting or a drawing as precisely as possible into an etching or an engraving. Today cameras provide cheaper, quicker and more exact copies than any engraver could achieve.

Such reproductions can occasionally be of very high quality, even printed in limited editions, albeit in fairly large numbers and sometimes, presumably under financial pressure, even signed by the artist. But they are not what is now accepted as an artist's original print. They are simply copies of a work which was conceived in another medium and their intrinsic value lies only in the enjoyment of the owner.

The contemporary art world is generally interested only in true ORIGINAL PRINTS, where the artist may use any printing method to create a work which is new, based firmly on the medium of printmaking, and so by its very nature also capable of being repeated. Since at least the 1960s, these almost always appear in a limited edition, just occasionally in editions of 200 or 250, more often in editions of only 10 to 75-100. Each print in the edition is signed *and* numbered for authenticity.

The term was formally established in the 1950s and new technology is pushing the boundaries of printing methods all the time. But there is absolute agreement on the fundamental requirement of originality; the artist conceives the image as a print, not as a painting; he or she may work directly on the printing surface or may supervise those who do, but he or she is involved at every stage and gives final approval to the finished print. The only exception to this is when the artist has died and the print is published posthumously with estate approval, and clearly marked as such.

This book is concerned with original prints which were made within the past 110 years, i.e., the whole of the 20th century, a little before and a few years beyond. But a little background might be useful.

When the Royal Academy of Art was founded in London in 1768 it refused to accept engravers, considered "mere" craftsmen, not artists, unless their reputations rested firmly on painting or sculpture. So Rembrandt and Dürer, both fascinated by printmaking, would none the less have

qualified, but Andy Warhol, because of his intense concentration on creating prints, might not have.

This attempt at separating themselves from the crafts and guilds was not surprising. Artists were battling to be accepted as the professional equal of architects and musicians. Anything which smacked of pure skill was to be avoided.

At the same time, the financial benefits of reaching a wider audience were obvious; those artists whose work was turned into prints by commercial engravers were able to earn considerable sums for the most popular subjects.

But if the artists could distance themselves by merely allowing copies to be made of their paintings, they could take the royalties and still lay claim to the finer airs of "pure and fine art".

All that began to change towards the end of the 19th century. For the public, the development of photography was making pure reproduction less profitable. For the artists, a vital factor in their own changing attitudes was the earlier invention of lithography and the subsequent refinement of colour lithography in the 1860s. For the first time an artist could enjoy the same freedom of brushwork on a stone or plate as on paper or canvas.

Printers were also honing their old etching and engraving skills and developing new ones to take advantage of every technical invention. Many turned their attention from commercial mass-market printing to collaboration with younger and less

hide-bound artists willing to see what might be done in this new and exciting medium.

And the last support fell into place with a new breed of publisher, quick to see exciting new ideas growing fast when artist, printer and publisher partnerships poured out posters, illustrated books, and even magazines as well as individual prints. Especially in Paris, the centre of the art world in the 1900s, and gradually in the rest of Europe, the publishers commissioned more and more work, involving both artists and printers continually in every aspect of production.

The world outside Paris began to take note. Students arrived at the ateliers to learn new crafts, and left to take their knowledge elsewhere. The two World Wars slowed everything down, but by the 1960s printmaking was exploding again, particularly in England and America, with a new generation of printmakers in Europe expanding technology every year.

And so a completely new medium has arrived for the artist, the student, and the viewer and collector. Far more complex, the making of modern original prints demands creativity, skill, dedication and absolute standards from everyone involved in the production. For the first-time buyer or experienced collector, learning the subtleties of the art, looking at the choices that are available, understanding the technical skills involved and, above all, seeing new prints and new artists as often as possible, will bring a source of infinite pleasure as well as an investment at a very affordable cost.

THE ARTIST MAKING PRINTS

Once informed of the qualities of an original print instead of a reproduction, the next logical question is why should an artist create a print instead of a painting?

It requires just as much creative input and it can take many weeks to prepare, through the completion of an edition. Often a collaborative venture, with paper-maker, printer and artist all involved, such potential also includes a greater chance of things going wrong and an image having to be abandoned.

Even when all three responsibilities are with the same person – i.e., the artist makes or buys in the paper, creates the image, and

prints the result – there are multiple technical problems a long way from the relatively simple equation of artist plus paint and canvas or paper. So why choose to make an original print at all?

The answer surely lies in the individual temperament. For some artists there will never be a worthy challenge beyond the immediate, and they are happy to leave it to technicians to turn paintings and draw-ings into reproductive prints, if these are wanted.

For others the technical aspects them-selves become a unique medium. Print-making offers so many varied and exciting possibilities that are simply not available in the "single-handed" mediums. The flat and yet velvety black depth of mezzotint that cannot be obtained any other way, the gentle line of drypoint, the layering of screenprinting, the ultra-sharp line of the etching needle, the powerful contrast of a woodcut, and today the myriad photo-graphic processes that can be combined to make entirely new effects – all are characteristics of the printmaking medium.

No wonder that since the 1960s, especially in America, and again since the 1990s internationally, there has been an explosion of technical and especially digital invention in the various printmaking processes. This has also had the desirable result of encouraging young students at art schools to take printmaking seriously, and so new artists keep re-discovering the

Clifford Hatts: PRINTING, *lithograph*
A student in the 1950s uses his teacher as a model, working on his own at the press.

Tom Robb: LAKE COMO, *watercolour, 2002*
Sketch sent home as a postcard which will be turned into a print in the studio (see p.163).

pleasures of working either alone or together to try this ever-evolving craft for themselves.

As a consequence of the change in status from craft, however skilled, to genuine participation, more and more printers working commercially in studios are coming to the trade with an art education which is also helping to revitalise every aspect of the process.

Alongside the huge input of new technology has been a growth in the popularity of art in general. Galleries have opened with a strong trend towards contemporary art as part of a lifestyle. This may mean clients have less to spend on individual pieces, but would-be collectors learn that original prints offer everything, from the most famous names of the 20th century to the first attempts by graduate students. And at the kind of prices which can make it possible to buy both!

An active, lively market means that the artists who need income to allow them to continue working are encouraged by the financial benefits of relatively inexpensive multiple images. And with careful support from the printer and publisher, the quality of their work need never be compromised.

The pleasures and delights of achieving satisfying creative results, often unexpected or unusual, bring artists back to the print over and over again. The beneficiaries include the buyer who could never afford a similar standard of paintings. This can only be the best possible result for those of us who love prints in all their amazing and continuing variety.

ESSENTIAL A-Z: What you need to know

Note: Terms are generally relevant to modern and contemporary print collecting. For most 19th century and earlier techniques, see BIBLIOGRAPHY p.188. For more technical information about printmaking, see PART FOUR, pp.128-163. All cross-references are in small capitals and those without page numbers will be found alphabetically in this section.

Acid-free
Protective tissues, papers, mounts etc. manufactured from the 1950s without acid; essential for all fine art as well as documents and photographs. Sometimes called archival/museum papers. See CARE AND CONSERVATION, p.116.

Acid tint
Developed in the US by Ken Tyler, a process involving burning an inked stone with nitric acid. The result is an image in tones of grey.

Acquaforte, all'aquaforte
Italian. All etchings, not only aquatints.

Affiche originale
French. The posters made by an artist, usually for their own shows or for friends, often signed and sometimes numbered. Today most posters will be photographic reproductions, although the best are valued for their design, especially when they advertise an art exhibition.

A la poupée
French. A method of dabbing paint through a screen by hand with a bunched cloth, or *poupée*. The catalogue description of a screenprint may include this term indicating the handwork involved in the production.

Algraph
An aluminium plate lithograph.

All digital print
An image which has been entirely produced on a computer printer, such as an ink-jet or laser. Some artists, especially those working on their own, use computers for both originating and/or printing; information given by the artist should include this. See COMPUTERS IN PRINTMAKING, p.162.

Aluminium plate lithography
Metal plates, either aluminium or more often an alloy, replacing the stone.

Antiquarian
A large paper size (790x1350mm, 31x53in).

Aquachrome
A complex colour technique involving photography and a gelatine surface.

Aquatint
Traditional etching medium; a dusting of resin, heavy or light, is hardened on the plate. The ink will print around the tiny white dots of resin to create a variety of half-tones when printed. Look through a glass to see the white dots (a small section diagram is magnified below). Or resin, asphaltum, or bitumen dissolved in spirit is left to dry on the plate leaving a regular crackled pattern.

AQUATINTA-VERFARHREN
German. Aquatint.

Archive impression, AI

Mainly US, the print taken from the edition for the archives, or records, of the printer/ publisher. Should be listed among the proofs in the PRINT BOOK.

Archival paper/archival boards

See ACID-FREE.

Archival printing inks

A problem for artists and printers has been the tendency of all pigments to fade in sunshine or artificial light over the years. Archival inks now used by printers are guaranteed to last from 50-100 years.

Art paper/art board

Paper with a coating of china clay which gives a very smooth surface receptive to printing inks. The colour gives a high degree of clear bright hues. Glossy art paper is traditionally used for illustrated books because it adds extra brightness to the colours, but most artists and print-makers prefer the matt version which appears more painterly.

Artist's books

Putting the finest text and pictures together has always been an ideal for art publishers. In Paris, around 1900, the first modern artist's books were published by Vollard. Most were either poetry or classic French texts; Bonnard illustrated Verlaine's poems, Chagall illustrated Aesop's Fables, and so on.

But Vollard also produced volumes of prints by many artists of the day, as had been done for centuries. Other fine art publishers have continued the tradition, especially in Europe.

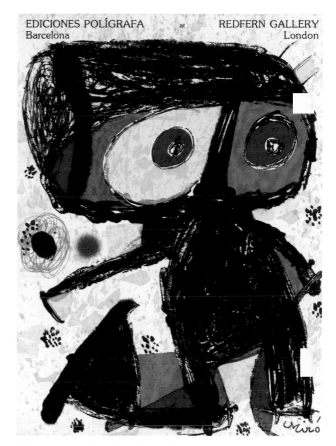

The cover of the Redfern Gallery catalogue of EDICIONES POLÍGRAFA, *1979-80. Design and lithograph by Miró.*

The Redfern Gallery in London, which specialised in prints, produced limited edition catalogues of some exhibitions of other print publishers containing original lithographs. These have been often un-recognised until recently, but now are priced at an appropriate level for the major artists included.

However, there are probably some dusty unnoticed copies in second-hand book-shops. Occasionally the same images were also printed on larger sheets and sold separately.

Modern artists' books fall into two fairly distinct categories. The first consists of projects which include the making of small books or paper objects in a variety of shapes. These are generally by artists who have written the text, produced some appropriate images and manipulated the paper and binding. Some are one-offs, others have small editions of 10-30. Although there are intriguing examples of printmaking amongst them, the emphasis is not on printmaking as a medium but more on a personal statement. Look for these at Artists' Books fairs.

The second category is the inheritor of private press printing and follows the great tradition of the 1900s onwards, based on well-chosen texts, illustrated by commissioned artists, produced on fine, usually hand-made paper and almost always, but not uniquely, in limited editions.

Far from dying out, this kind of artists' book, which features a small team paying great attention to all the relevant details, has had a real revival from the 1990s. There are excellent small presses today, often unknown outside their devoted clients, and mostly working outside major publishing circles. The prints are commissioned from well-known artists, as well as from etchers/ engravers who are, perhaps, not as well known as they should be.

See COLLABORATIVE PRINTMAKING.

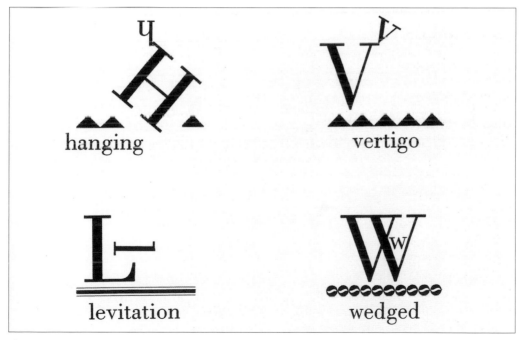

Opposite
One of John Piper's illustrations for Elizabethan Love Songs, *published in 1955 by The Cupid Press, numbered and signed by the artist.*

Above
Nicolas McDowell's BODONI CHARADE *for a miniature artist's book based on the Bodoni font, and manipulated with a computer.*

Although many art books of all kinds, especially in the '50s and '60s, were broken up and their prints framed and sold separately, their true value has now been established, and the best fine book publishers with access to a lively and interested market are thriving.

Such books can form a marvellous collection, usually at a much lower cost than the purchase of a similar number of individual prints. Unfortunately there are relatively few places to see them, but there are fairs and newsletters as well as helpful dealers. See SOURCES AND RESOURCES in PART FIVE.

Artist's portfolios

Aside from the actual portfolio case, this term is the accepted description of the publication of a set of prints. These may be a grouping such as an artist's work for a particular project, or new work, perhaps variations on a single theme, or a group of artists contributing one or two prints each to make up a tribute to a fellow artist, a movement, a gallery, or to celebrate an exhibition, a printer or a publisher.

Portfolios, unlike books, are seldom bound into a case, but are loose in a card cover, with protective glassine sheets in between,

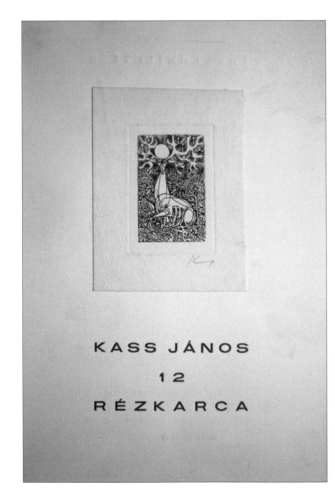

KASS JÁNOS

1 2

RÉZKARCA

and sometimes a separate sheet detailing the titles of the prints, the number of the edition, etc.

Portfolios can prove very attractive to a collector as they allow the purchase of a complete set, always a good point in the value stakes, and usually at a price which is better than the total of the individual sheets.

When some of the sheets from a portfolio are framed, extra care must be taken to ensure that the framing is easily dismantled so that they may be returned to its original condition if required.

Artist's Portfolios

Above
COUNTRY, *Polly Hope's linocut in a group of collages, prints and drawings.*

Opposite
The portfolio of twelve of János Kass' etchings,1972, MADACH, *with one of the very small etchings inside.*

Artist's proof(s) (AP, A/P)
It is now customary that the artist has an additional percentage of a limited edition for private use, to sell or to give away or to keep. The current customary number is 10-15% of the edition. These should be numbered with roman instead of arabic numerals, although sometimes they are marked AP in pencil, or the words Artist's proof are written with or without numbering.

Although not always noted on the invoice or label, the buyer of one of a small limited edition should always be told the number of artist's proofs as well as the number of the additional working proofs. Although the addition of 30-40 perfect prints to an edition of 300 will not be significant, 10-15 added to an edition of 100 may start to affect the resale value.

Artist's Proof. The pencilled mark on the bottom of the print on p.84.

Artotype
Another name for COLLOTYPE.

Assemblegraph
A print taken in one pass from a group of printing blocks set together in a larger block. See JIGSAW PRINT for another method of multiple block printing.

Auto-
Before "original print" was accepted, auto- in front of the process indicated that the artist had made the matrix; it was not photographic reproduction.

Authorised edition

After the death of an artist, a matrix may be printed under the authorisation of the artist's family or estate. Even when issued by the artist's usual printer, there is always a certain amount of caution needed in evaluation of quality, as the artist could not have approved it. See right.

Autotype

Carbon printing, collotype. Also the German and Dutch word for half-tone photo-engraving.

Avant les lettres, before letters

The last pull of an illustration that will eventually have printed text but proofed before the text line is added, which gives the names of artist, printer/publisher, with the title generally in the middle.

Bat proof

From the French *Bon à Tirer, or* Good to Print, in the US known as RTP, or Right to Print. This is the final proof signed off by the artist and by the printer, the authorisation which allows the edition to start. During the printing each sheet is checked against the BAT.

Even in commercial printing a publisher of fine illustrated books will watch the first sheets off the press and the full edition is not started until the BAT is signed. See PROOFS, PROOFING for full description of the many working proofs.

After editioning is completed, the BAT is carefully packed and stored by the printer against problems with damaged or rejected prints.

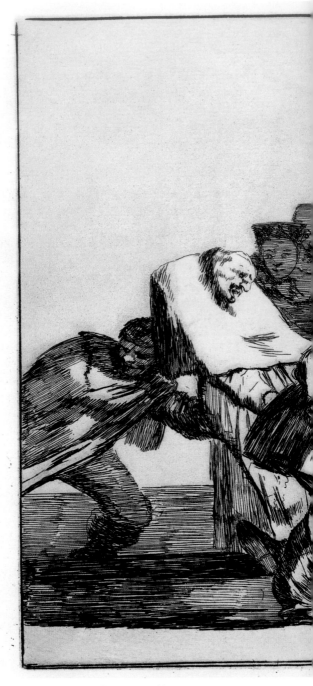

Authorised Edition. Goya's etchings, LOS PROVERBIOS, *of which this is one, were published perfectly legitimately in a third edition in 1893, after his death.*

The eighteen prints were folded and pasted into a leather-bound book; the fold leaves an obvious crease. Much more important, without the control of the artist's approval, the quality has suffered considerably. Gradually the plates have worn down and there are many gaps in the lines, noticeable in the plate impressions.

Bat printing
Transfer printing on to a ceramic surface.

Baxter print
A kind of print invented in 1835 by George Baxter, in which a monochrome aquatint is overlaid with colour woodblock printing. Very popular in the Victorian period. Still collected avidly.

Bled image, bleed print, bleeding
When the image extends right across the paper leaving no margin, the image is described as bleeding; the print is a bled image or a bleed print. The signature, number, etc. will be written on the back.

Such a print must be handled with exceptional care, as there is no protective margin. It will also need to be framed quite differently so that the entire image is visible. See FRAMING, p.124.

Blind embossing
An embossed line; the paper is pushed into the incisions to create a raised pattern without ink. Some prints are blind embossed to outline parts of the design like trapunto work in quilting. CHOPMARKS are often blind embossed.

Blind embossed chopmark
Left, the chopmark as it appears to the eye on the margin of the print.
Right, the chopmark area darkened to show the embossed design which identifies the printer. Will be noted in catalogues, and helps provenance.

Block
Printing matrix, usually wood or wood with a linoleum layer.

Board
Any paper heavier than 90lb per ream or 220gsm.

Bon à tirer
French. See BAT

BS7876
The British Standards Institute in 1996 clarified the categories of printmaking and distinguished mere copying from those prints where the artist was involved in the print production.

Buckling/cockling
US and UK terms respectively for paper which develops a wavy surface. It can occur through poor making, storage, or a damp environment.

Burin
Steel engraving tool, graver.

Burnishing
Using any hand-held tool as simple as a rounded stone, or the back of a spoon, to press paper over a surface to make a print without a press or to add some detail after the print has been pulled from the press.

CAD/CAM
Computer aided design, computer aided manufacture.

Cael, caelvit
Latin: "engraved by" seen on some old prints.

Cancellation
An etching which had been properly cancelled, with scratched lines. However, the plate was purchased, repaired and reprinted for study. The new prints were not offered for commercial sale.

Calcographia

Spanish and Italian. A generic word for all forms of printmaking; also a museum of prints or a collection of prints.

Calendered paper

Made smooth by rolling to stop the paper stretching while it is being printed. Particularly vital when a print has to be laid down on the press several times with the correct registration to ensure that the colour will be in the right place.

Cancellation, cancelled

With the increase in limited editions, it becomes vital to ensure that any printing surface is "cancelled" so that no further prints can be made. A plate or block may have lines scored across the image, a stone will be ground down, or acid used to destroy the surface.

Cancellation proofs

Made for the studio to prove that an original plate, block or screen, etc. was destroyed or defaced to avoid being used again. Unfortunately, the temptation to reuse popular old plates caused some unscrupulous printers/publishers to try to restore the surface and reprint, especially after the artist's death.
See RESTRIKE.

Chine collé. In this detail of a still life by Margaret Knott the colour on the left-hand top of the print has been made of thin tissue paper, glued down in the chine collé method.

The tissue paper is glued, laid face down on the plate, and the paper laid on top and printed over the tissue.

Carbon print
Developed 1855-1864, using a tissue which is treated with gelatine and light to make a printing surface. The resulting print can also be called an autotype.

Carbon transfer print
A process involving a form of carbon tissue which uses three-colour tissue.

Carborundum print
An extremely hard abrasive called silicon carbide grit is used. The image is drawn on the plate with glue and the grit is sprinkled on and allowed to dry. The excess is dusted off before printing. The grit provides a key to hold more ink, giving extra depth to the colour.

Catalogue raisonné
For research on a well-known artist the catalogue raisonné is a primary tool. This is a list of all works accepted as genuine at the time of its publication. Although quite expensive, such a purchase is absolutely essential for the dedicated collector. A caution; they are revised from time to time to include new research.

Chiaroscuro print
Italian. Shadow; used to describe a kind of woodcut when three separate blocks are cut to print light, medium and dark tones of a single colour. Rare today.

China or India paper
A thin paper originally made in China and imported through the East India Company; still used for Bibles, small diaries and other weight-restricted printings.

Chine collé
French. Tissue or china paper glued on heavier backing paper, used for its special texture, often as part of a collage.

Chopmark
An blind embossed stamp in the corner of a print (usually but not always on the right) or underneath the image. This is the identifying mark of a printer, publisher or studio. Chopmarks are noted in good catalogues as they can be quite difficult to fake. See WATERMARK for a way of identifying the papermaker and the particular quality of the paper. See also BLIND EMBOSSING.

Chromiste
French. The craftsman who transforms an artist's design into a printing matrix. Often shortened to chromo.

Chromocollograph
A COLLOTYPE with colour.

Chuban
Japanese paper size, 394x265 mm (15x 10in).

CIJ
Continuous inkjet printers. See also GICLÉE.

Clay print
Relief made from block of clay which is then hardened and can be printed, but only by hand to avoid too much pressure.

Cliché verre print
French. A design engraved on darkened glass to create a negative, which can then be printed photographically.

Clipping, clipped
A print that has been trimmed so close to the image area that there are little or no margins. Even the platemarks of intaglio prints have sometimes been trimmed off. *Not* prints which are deliberately printed right to the edge, leaving no margins.

CMYK
The four colours of commercial half-tone printing and photography: Cyan (a bright turquoise), Magenta, Yellow and Black.

C

An artist's print has colours made up individually and so the range is far wider and more accurate in interpreting exactly what the artist requires.

Coatings, coated papers
Paper coated with china clay or emulsion. See ART PAPER. Some modern coatings are coloured with inks or with metallic or texture finishes.

Cockling
UK: wavy paper. In plain sheets it can happen at the paper mill when the damp paper is packaged too quickly. In finished prints, or in framed prints, it is usually the result of dampness. US: Buckling.

Codex
Technical term for an early book, written by hand and with illustrations.

Collaborative printmaking
A fairly modern term which celebrates the cooperation of printer and painter in the creation of fine printmaking. With this collaboration the printer takes a rightful place in the exploitation of the medium, and in the development of new individual techniques which have pushed printmaking ahead, alongside the artist. None the less, their names are seldom as well known to the general public.

In the past artists seldom made prints as such; they painted watercolours, oils or made drawings which were turned into prints by professional and highly skilled craftsmen. With Turner, for example, the only record we have of many of his paintings are the engravings that were made "after" them.

There were always a few exceptions – Rembrandt was known to have carried copper plates to engrave landscapes – but the invention of lithography, then colour lithography, and, in the 20th century, screenprinting, meant that artists could see how their natural skills in brushwork could be made much more easily and directly on to stone or plate.

But no matter who made the image, the skill of the printer could not be underestimated and from the 1900s on Ambroise Vollard was encouraging his favourite artists by teaming them with the finest craftsmen of his day.

Posters and lithographs by Toulouse-Lautrec, Bonnard, Vuillard and Redon were created under the guidance of Auguste Clot, lithographer. Etchings by Picasso (including the famous Vollard Suite) and other artists were largely created with Roger Lacourière. Stanley Hayter's Atelier 17 began in Paris, too, although it moved to New York after WWII.

France had become the home of the best print studios, where skills were practised and taught to apprentices and sometimes to students coming from all over the world. Their legacy is still a potent force, mentioned in reference books, thus assuring the reader of the quality of the prints. Their apprentices became teachers, who in turn taught some of our finest printmakers today.

From the middle of the last century, in France Gustave Mourlot and Maeght Editeur continued the tradition; as well as the Mourlots, the Crommelyncks, father and

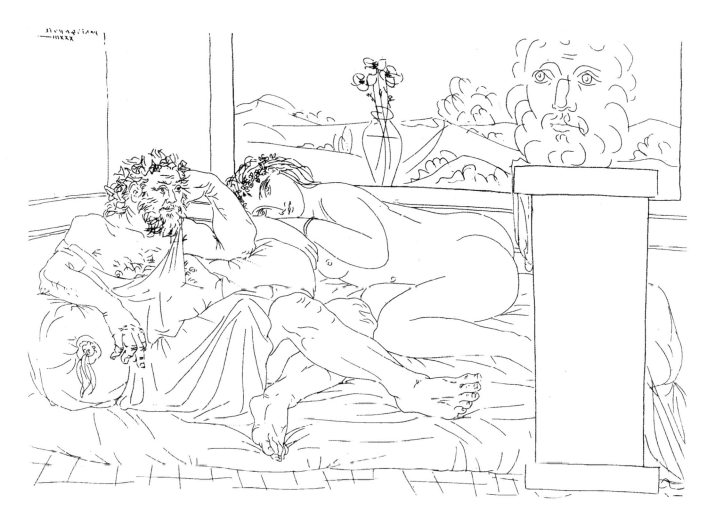

Collaborative printmaking. Detail from RECLINING SCULPTOR AND MODEL, *no 65, Pablo Picasso, etching 1933. Picasso's Vollard Suite was a remarkable collaboration of Ambroise Vollard, publisher, Pablo Picasso, artist, Roger Lacourière, printer, and Montval, paper maker.*

The entire work of some 100 plates made between 1930 and 1937 owed its inception to the publisher, but the final quality of printing to the skill of Lacourière. 250 copies were on Montval paper, watermarked Vollard or Picasso, and a final 50 copies were printed and watermarked on Papeterie Montgolfier à Montval.

C

son, worked with artists who came from all over the world; Picasso, Braque, Richard Hamilton and Jim Dine…

In the UK there were book presses illustrated with fine prints, such as the Curwen Press, and a plethora of fine art book publishers who commissioned prints, as Vollard did, for classic or new texts. Printer/publishers like the pioneering Editions Alecto and the Kelpra Studio left an indelible mark on the field and these days Paragon Press and Advanced Graphics, among many others, continue in a flourishing market. There are galleries, too, involved in publishing prints: Waddington Graphics, Flowers Graphics, the Alan

Cristea Gallery, and Marlborough Graphics – many more are beginning to both show and publish for their own artists.

It is also a feature of the past century that printmaking is now taught enthusiastically in the best art schools. One of the results of this transformation from pure craft into a respected art form is that printers and printing colleagues are often artists themselves, especially receptive to ideas and concepts, and ready to play a full part in the collaborative work.

In America the tradition of teamwork came later but is now perhaps one of the strongest in the world. The Tamarind

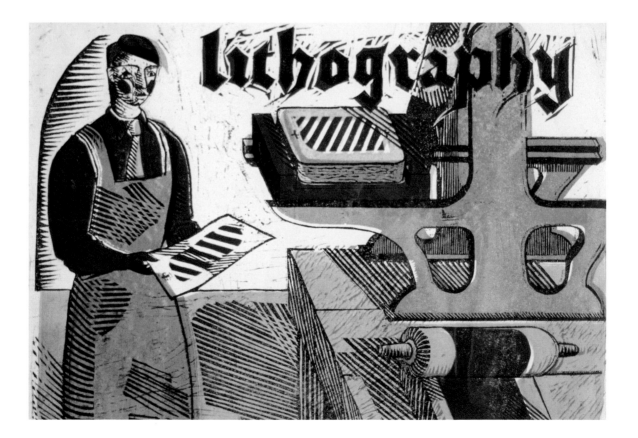

Collaborative printmaking.

Opposite
Clifford Hatts: LITHOGRAPHY
Frontispiece for book of prints

Below
Victor de Vasarely: no title. Etching inserted into book of poems, Code, *by Jean-Clarence Lambert and published by Editions Soleil, Paris.*

With a green cloth binding and slipcase, the front cover design and separate etching were by Vasarely. Many printers worked with authors and artists and book binders in producing a collaborative work.

Below
Ruffino Tamayo: FIGURE, *lithograph*
One of a group of lithographs published by the Redfern Gallery in a limited edition in 1979-80 as part of an exhibition of the work of EDICIONES POLÍGRAFA, *a well-known Spanish printer/publisher. A similar show exploring the work and achievements of* EDITIONS ALECTO *was put on in 2003 at the Bankside Gallery, London.*

C

Institute directed by June Wayne, originally in Los Angeles, then in Albuquerque, New Mexico, has a programme which brings their graduates respect all over the world. Landfall Press in Chicago had Jack Lemon and David Keister as master printers until David moved to Indiana and was a founder of Echo Press, part of Indiana University. Ken Tyler Graphics, with Ken Tyler at the helm, was one of the most innovative studios on either side of the Atlantic until he retired. These are only a few of the highlights of contemporary collaborative printmaking; there are many many more.

For the collector, especially a novice, the name of an established printer may be almost as vital as the artist, and can teach as much about the quality of the materials and the care in the operation of the process as any reference book. Indeed, some fine collections have been made concentrating on the printer rather than the artist.

Learning more at first hand about the process of printmaking will lead to better appreciation of the skills involved; some art schools and studios have open days for the public, so you can observe how each kind of print is made. The Victoria and Albert in London and the Smithsonian in Washington are two museums with displays which set out the history of the craft in considerable detail.

Opposite
Collaborative Printmaking.
Paul Jenkins worked with Maeght Editeur to create some of his most attractive prints.

Collage
French: from *coller*, to glue. An image made of different pieces – paper, fabric, ribbon, found objects like shells, wood, scraps, older prints, etc. – glued together.

Collagraph
UK: a print taken from a collage base. Since many of the materials may be more absorbent (fabrics, newspapers, etc.) than the underlying plate, the surface of the finished collage is usually sealed before printing.

Collograph
US: the same as collagraph.

Collotype
A 19th century print made using gelatine to create an image which has a texture like an aquatint. Printed like a lithograph, it was originally used for reproductions, but it has been revived for the appeal of the irregular gelatine surface

Colophon
Text giving author, printer, edition, etc., in Europe often the last paragraph of the final page, in a portfolio of prints usually on a separate sheet and signed by the artist. In books it appears on the back of the title page. Also in general publishing the company emblem or logo used on the spine and title page.

A colophon for the Old Stile Press by Harry Brockway

33

C

Colour fastness

Technical measure of how long a pigment will retain its true colour. Artist's paints are usually given stars to indicate the degree of lightfastness, from excellent down to poor. But light levels, humidity and type of glass over a print will all play a part.

Inkjet and digital prints continue to be suspect because their original inks were likely to fade over a relatively short time, but modern technology is increasing this fastness and new inks are proving more reliable. See p.163.

Colour print

A print which is made with more than one colour. The opposite of monochrome.

Coloured print

A distinction from the previous term and often misunderstood, this is a monochrome print which has been coloured *after* printing, by hand or with a stencil, sometimes by the artist, sometimes in the studio. The similarity of the two terms can be misleading to the new collector.

Colour proof

One of the trial proofs used to check the registration and degree of colour before an edition is printed. It can also be used to try out a variety of colours for the final choice by the artist. Colour proofs are also used to show the effects of the sequence of printing when there are overlapping areas.

These are occasionally marked simply TRIAL PROOF, but most often marked CP and kept with the PROGRESSIVES for reference by the printer.

Opposite
Colour fastness. A Maillol lithograph used for the cover of Verve, *an art magazine published in Paris in the 1930s-1940s.*

Bound in paper, it used many of the newest technologies of the time, and, aside from fascinating articles on a variety of subjects, contained a number of original lithographs as well as reproductions of drawings, paintings, photographs, etc. Copies of Verve *are now eagerly sought by collectors.*

Exposed to light all the time, the Maillol lithograph has faded very badly. There were larger areas of green, especially between and below the two women, which have disappeared on this copy. A warning to us all. It should never have been kept on the open shelf, but slipped inside a portfolio, or, at the very least, had a light-resistant cover.

Colour proof. Detail from SUN CITY, *Paul Derbyshire, lithograph 1988.*

Two colour proofs which show how much change there can be with only the tiniest addition of more red to the ink.

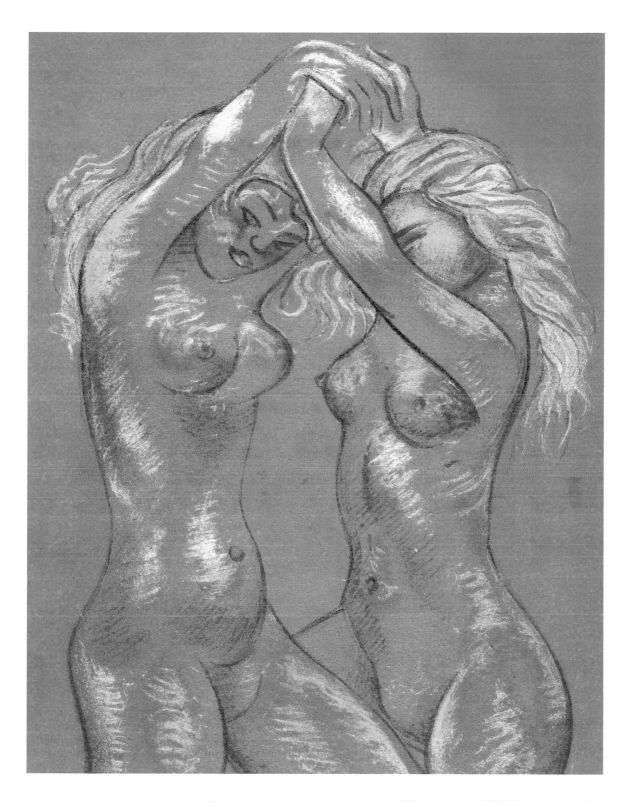

C

Colour saturation
The intensity of any colour, dependent on the amount of pigment used in the ink.

Colour sequence
The order in which colour over colour is printed will have a profound effect on the final result. Some presses include this information on paperwork for buyers.

Combination print
One of several terms which describe a combination of mediums – aquatint, drypoint, collage, and etching, perhaps – all on one print. Also called mixed media.

Compound print
See JIGSAW PRINT

Computer generated print
An original work of art which has been created and printed out on a computer.

Computer manipulated print
An original drawing or painting which has then been scanned into a computer and developed to create a new image.
See below

Concertina binding
A form of binding for an artist's book, or a sequential group of prints, where a long sheet is folded up concertina style.

Continuous tone
The even shading from light to dark; it can be achieved through a variety of processes. See PART FOUR.

Cooperative printmaking
Embodying a very strong relationship between master printer and artist when they are separate individuals. With such cooperation, usually centred around a Press or Studio, artist and craftspeople together can develop new and exciting

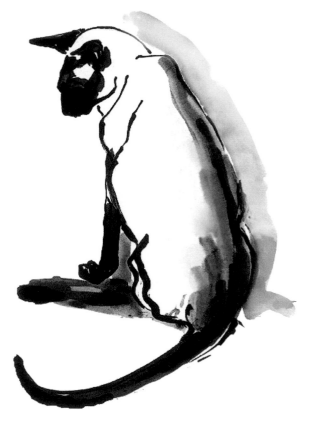

*Computer manipulated print.
GRANNY by Alan Taylor.*

This was drawn, scanned and then transferred to a computer. The lines were darkened on the side of the cat to create a stronger contrast.

Although some computer imaging is extremely smooth, like this one, those drawn directly on the computer can show pixellation. Many artists prefer to leave this as the mark of a new medium, not something to be disguised.

possibilities. See COLLABORATIVE PRINTMAKING, the term used most often for longer essay and more details.

Copper plates

Engravings are cut directly into copper plates. Copper is soft and easy to work. For longer editions the plates can be STEEL-FACED. S.W. Hayter (ATELIER 17, p.166) was the quintessential engraver of modern times.

Because of this historical tradition, *copper-plate* is also a generic term, still occasionally used for all intaglio presses as well as the prints made on them.

Copyright

The ownership of any work of art. Traditionally, although the artist owns the copyright in the design or image, the copyright in the print belongs to the printer/publisher, unless the artist has specifically stated otherwise in an agreement. Of course if the artist has also printed the work there is no agreement necessary.

Copyright becomes important for collectors if they are asked to allow their prints or paintings to be photographed for any commercial use. They have the right to give permission for the photography, because they own the print, but the photograph cannot be used except for their private records without the permission of the artist or the owner of the copyright.

Cork prints

Relief prints have been made from a number of appropriate surfaces, including cork and linoleum. Both cork and lino, being relatively cheap, are often used in schools, but each also has an individual texture which may appeal to the artist. Cork gives a random speckling in the background, lino may result in slightly crumbling edges around the cuts.

Counterproof

One of a series of trial proofs. A just-printed proof, still wet, is covered with a sheet of usually thinner paper, which itself picks up the ink and gives a faint impression of the original.

The purpose is that, although the original print gives the correct image, the counterproof is the reverse, just as the block is, and so it is often easier for the artist or printer to locate any corrections on the plate.

Cross hatching

Originally one of the only ways to achieve tone, it remains a difficult technique in etching because the little spaces between the crossed lines tend to break down under pressure during printing, leaving blobs in the design. Below it has been considerably magnified.

Crown

A paper size 380x508mm (13x20in).

D

Dab print
Dabbing is applying ink on to the surface of a block by hand, using a cloth or a brush. It allows for subtle variations in tone and colour, and is especially useful for small areas when it would be laborious to create separate blocks.

Daguerreotype print
An early form of photography, the daguerreotype can have an electrotype taken from it for reprinting. Very rare.

Damp paper
Relief and intaglio printing is usually done on damp paper – generally, paper absorbs the ink better when it is damp. This is one of the explanations for SIGNATURES in pencil on newly finished prints – ink would bleed.

Date
Limited edition prints show a date, either the date of printing or when the artist made the matrix. Sometimes this will be extended (say May 53-June 54) when the artist has worked on it over a long period.

Deckle
The best prints are usually on hand-made paper with an irregular edge, called the deckle. It is now possible for machine-made papers to imitate a deckled edge, but it is usually too regular to be convincing. When a print is edge to edge the deckle becomes very obvious, an attractive feature which should not be covered up in the FRAMING, p.122 (window mount).

Delineavit
Latin: he drew…abbreviated to delin, delt, del, on older prints. See DESSINE.

Demy
Paper size, approx 444mmx571mm (17½x 22½in).

Depot legal
French. The French law which requires deposits of all published work in a national archive. In France this is the Bibliotèque National, in the UK the British Library, in the US the Library of Congress.

Derby print process
The Bemrose and Sons print company in Derby, England, developed their own form of offset lithography around 1915.

Dessiné
French: drawn by…

Digital prints
The latest technology for both creating and producing prints involves many digitally-driven processes. It is important that any print which has been created with any of these should be identified in writing.

Because the matrix of a digital print can produce as many copies as required to the exact same standard, and can be copied electronically in minutes, it makes it even more important to the collector that the printer or artist gives absolute assurances for limited editions.

Dotted print
Early technique in which an intaglio metal plate was punched with jeweller's tools and printed in relief. Some experiments were done in the 1970s to adapt this for background textures in etching.

Double

Any paper size double the original; double crown, double quarto, etc.

Double spread

Two facing pages in a book which are often designed as a single image. The Goya print illustrated on pp.22-23 shows the central crease of a double spread.

Drypoint

A traditional intaglio technique which uses a very hard tool, a drypoint needle, to engrave the image. The point throws up a little curled spiral on either side, called a burr, and by holding additional ink either side of the line it gives the print its characteristic soft appearance. When printed, the burr wears away much more quickly than the surface of the plate, and within 10-20 prints that softness will have disappeared, so drypoint prints generally exist only in small numbers.

Although most drypoints use a metal plate, especially copper, it can be done on something as ephemeral as card, which will let the artist take perhaps three prints before the burr collapses.

Artists who are interested in creating a print for long editions will avoid drypoint. For the same reason, drypoint etchings are quite highly sought after by those collectors who enjoy knowing they have something scarce.

Digital print. Alan Taylor: GOAT'S HEAD, *showing its computerised origin clearly in the pixellated outlines.*

Drypoint with aquatint. Tom Robb: WALKING TO TOWN. *See previous page and* PART FOUR *for more information about drypoint.*

Edge to edge prints
Without traditional margins, these are printed right to the edges of the paper.

Edition
The number of a print which is intended to be published for sale. Not to be confused with a printing; an edition may go back on the press a number of times, depending on its popularity and requests for additional copies, and of course as long as the matrix remains usable.

An UNLIMITED EDITION may continue to be reprinted whenever required by sales. This was much more acceptable in the past. Today an artist/publisher will usually enhance potential value by restricting numbers. See also CANCELLATION, LIMITED EDITION, NUMBERING and DATE for additional information.

Some art books and almost all ARTISTS' BOOKS are issued only in LIMITED EDITIONS, which see. Limited edition numbers do not include proofs made for artist, printer, publisher, etc.

Edition proof

Proof kept by printer as record and reference for all future editions. Usually recorded as EP in PRINT BOOK.

Elimination print

See REDUCTION PRINT

Embossing

A deeper intaglio line has the damp paper pushed into it to create, when the print is lifted, a raised line on the surface. It is often used to emphasise an outline of some part of the image. When there is no ink used in the depression the raised line is called BLIND EMBOSSING. See also CHOPMARK.

End grain

Block of wood cut across the grain to provide a very hard, smooth surface for wood engraving.

Endpapers

Double-page sheets pasted on to the front and back of a book block to hold the block to the inside of the cover and to hide the folded edges of the cover cloth. Many endpapers, especially in artist's books, are decorative – they may be tinted a solid colour, incorporate an illustration like a map or a motif related to the subject, or be printed with an image made by the artist.

Engraving

A generic term often used, like etching, to encompass all prints. But an engraving is specifically a design which has been cut into any plate, wood, metal, lino, etc. by using a graver (burin), a knife or any other tool. Also used for the print itself, as well as for the image, or for any incised decoration such as monograms, presentation texts, etc.

Engraving is one of the mediums which make up intaglio printing. See pp.142-151.

EP

Initials used on proofs to indicate an EDITION PROOF which is used for reference by the printer. See PROOFS for other marks.

Epreuve d'artiste

French: ARTIST'S PROOF, often written EA.

Epreuve d'état

French: STATE PROOF, marked EE.

Estampe

French. Generic term for prints, especially intaglio, but also printers, publishers, a magazine. Specifically a print produced by craftsmen from an original drawing or painting by an artist. See next entry.

Estampe de tirage limité

French. An *estampe* in a limited edition and which may be of sufficient quality to be signed by the original artist.

Estate print

A print which has been published after the death of the artist and approved by his family or the heirs to the estate. To give it authority there may be a special stamp on the margin.

As with all posthumous printings, the value may be diminished as the quality can be lower than one printed in the artist's lifetime and which had his/her approval of the final proof. See AUTHORISED EDITION and pp.22-23, Goya caption.

Etching

Like engraving, often used as a generic term for all prints, especially by a seducer of innocent ladies. However, an etching is properly a specific kind of intaglio print. A metal plate is coated with an acid-resisting wax and the image is scratched through to the metal. An acid bath bites into the lines as deeply as required, depending on how long the plate is in.

Today many are made with aquatint to create tone. Etchings used to be mostly monochrome, but they can be printed in colours or hand coloured afterwards.

EX COLL

Ex-collection of. Used in catalogues to say who owned the print before and therefore add weight to the PROVENANCE.

Face

The printing surface of a plate or block.

Facsimile

A reproduction, but exactly the same size as the original and generally used to indicate a degree of fine quality.

Fake

A copy of a genuine original print sold as an original, or a new image, reproducing the style of an artist, perhaps called a pastiche, but which becomes a fake when it claims to be an original.

Legitimate copies have always been made for practice and study; only when one is deliberately passed off as an original does it become a criminal act.

Fax print

Some contemporary artists have become fascinated with the fax machine and have developed a technique to take advantage of it. David Hockney uses fax copies to create multiple images.

Fecit

Latin: he made. Usually the craftsman who copied the original art for printing.

Filigrane

French: WATERMARK.

Fillet

Narrow strip, usually wood or metal, which is used underneath the glass of a frame to hold it away from the surface of the print, where it may cause damage.

Filling in

A fault in printing, caused usually by over-inking or when the plate has begun to break down. Then the lines of the image are blurred by ink seeping where it was not intended to go. A print which has filled-in areas should not be accepted as part of the edition.

As with all other discrepancies which you believe may be a fault, the best way to find out is to ask to see other copies of the edition. In traditional printmaking it was relatively easy to see faults; today what used to be discarded may actually be an intended part of the artist's original concept.

Opposite
Fakes. After research, this "original print" by Francis Picabia was recognised as a fake, which cleverly made use of various motifs from his paintings.

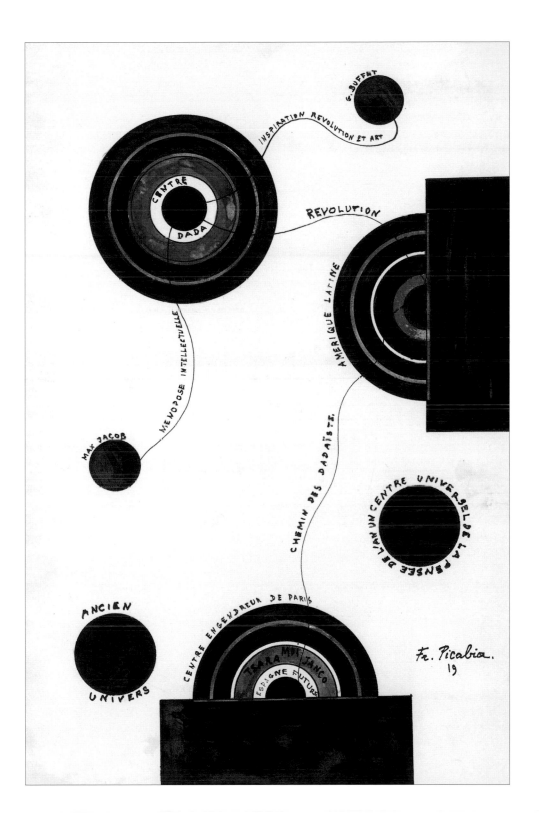

Flattening

New prints on their damp paper have to be dried carefully to avoid buckling. A damaged old print may be damped down again, then weighted with blotters and tissue paper until dry and flat. See PART THREE for how to avoid cockling.

Flocked print

An adaptation of an old wallpaper and textile technique. Wool or fibre in tiny strands is pressed or sprayed on to a surface printed with adhesive. Often used in small areas to create a textural contrast with smooth surfaces. As the surface is irregular, special care must be taken in framing; use an extra-deep fillet to hold it away from the glass.

Folio

The page number in a book; also a paper folded in half.

Forgeries

The inclusion of some "proof," like a printed or fraudulent signature, can be used to suggest that a possibly legitimate copy is a genuine original.

Other frauds include reproductions or pastiches in the style of a well-known artist. Being offered an extremely cheap price is always cause for concern. The more you know about the artist the less likely you will be fooled.

Foxing

Discolouring in reddish spots from a form of mildew, often caused by damp. Foxing can be eased away although removing it altogether is seldom possible without damaging the paper.

Frottage print

Printing by rubbing ink over very thin paper which is laid on a relief, or a carved surface. Brass rubbing is a form of frottage.

Galvanography

An electrotyping technique developed in the 19th century, now occasionally used to make an etching. When electrotyping is reversed, and the metal is deposited on the matrix, it makes a relief print.

Ghost image

When the lithographic stone or a silkscreen has not been cleaned properly, a previous image may appear on the new print. Obviously these should not be passed for inclusion in the edition, but sometimes they appear on trial proofs, which are subsequently sent for sale.

Ghosting

A halo around some parts of the print which may occur when the ink rolling has not been carefully handled. Reprints and restrikes hurriedly produced to satisfy the market can suffer from ghosting.

Giclée

French: sprayed. Used (although seldom in France, where it is sexual slang!) to identify prints made on ink-jet printers.

Buyers can be misled by this new term, not understanding that it refers only to the computerised printing process which can indeed produce very high quality photographic reproductions as well as images of computer-manipulated and computer-generated original prints. If in doubt, re-

place *giclée* with ink-jet in your mind to understand the description.

Glassine
Fine, transparent acid-free paper which is glazed to reduce friction and used to separate prints in store. Also used bound into fine art books to protect illustrations. See TIPPING IN.

Gravé
French for "engraved by".

Gravure
French. Used as a generic term for all print-making and in English also adapted for various processes: photogravure, helio-gravure, etc.

Group print
A print, usually a kind of mural, made by a cooperative of artists, sometimes as one piece or in separate sections.

Half-tone
The photographic reproduction of tone by means of a screen.

Hand-coloured
Hand colouring is practised to create colour on monochrome prints, or on colour prints which need additional details painted over the print. Sometimes when an artist adds colour himself he will sign the print again to authenticate it.

Hand-made paper
The finest prints are made on a wide variety of papers, but almost all will be on hand-made sheets. These, made in indi-vidual frames, are identified by having a deckle edge all around, while mould-made papers have a deckle on two sides only.

Most hand-made paper is heavy, but some JAPANESE PAPERS are quite thin; see for more details.

Hanga, Hangi
A generic term for Japanese woodblock prints, also their printmaking techniques.

Giclée. Alan Taylor: PORTRAIT OF JULIAN
A properly labelled ink-jet or giclée original print.

H

Hard Ground
Etchings are often described as hard ground or SOFT GROUND etchings (which see). With hard ground a stiff mixture is used to coat the plate before the acid bath and the etch is scratched or incised into it with crisp lines.

Heliogravure
French. Photogravure, also rotogravure, a process used for commercial printing before the development of off-set lithography, but also used by artists in photographic etching.

Heliotype
Synonym for COLLOTYPE, which see.

Heliogravure. One of a series of medieval portraits. Heliogravure prints of this period (1930s) were often sepia in tone rather than black and white.

Hinges
Hinges for mounting, made of a light but strong paper. Often torn into shape to allow the frayed edges to be glued inconspicuously to the print. Both hinge and glue must be acid-free. Japanese mulberry paper is the most popular.

Hoeschotypes
A process for producing hand-made collotypes with five tones of each colour, named for its German inventor (c.1870). Henry Moore was one of the artists who continued to use this form of printmaking.

Holzschnitt
German: woodcut.

Hors commerce, HC
French: out of commerce, meaning not for sale. These are extra prints, beyond the numbered edition, which are used for display, publicity or to hold in the archives. See PROOFS.

Hybrid print

Becoming more and more popular, these use a combination of traditional print-making techniques with photographic or computer imaging.

Ichimai-yei

A Japanese print on a single sheet.

Image

The whole of any work of art which is used to make a print, the design, the picture.

Impasto

From the general art term for heavily textured brush strokes, a three-dimensional matrix or printing surface.

Imperial

Paper size 560x760mm (23x30in). As this has been made for centuries there can be slight variations in output from place to place. If Imperial is the choice for a book of prints it should be ordered from the same mill.

Imprint

Originally the name of the printer, which must be shown on all commercial printing, but now usually referring to the name of the publisher instead.

Impression

A single print or a proof.

Impression mark

A faint indented line around the image when the lithograph stone or etching plate is smaller than the printing paper. Also called a PLATEMARK.

A false impression mark is when blank paper is put through the press so that the mark is made, but then a reproduction is pasted in the space. The result looks at first glance like a genuine intaglio print.

India paper

See CHINA PAPER

Infusion line

A natural fault on a lithographic stone which may show up under pressure in the press. Such prints are rejected but they sometimes appear on the market when the artist's work has become valuable.

Insurance copy

When an edition is finished, a few extra may be printed to replace any damaged sheets. This should be noted in the description of the entire edition. If they are not used, they may add to the number of extra prints which come on to the market.

Intaglio

One of the three basic forms of printing, intaglio is any image cut, incised or engraved below the surface of the matrix. See the next page for a diagram of an intaglio press.

Intaglio print

Any print from an incised or engraved surface where the image prints from ink in the cuts. In relief printing – its opposite – the image will print from any surface raised above the background.

Intaglio printing includes all forms of etching, engraving, aquatint, drypoint, mezzotint, and any combination of the above, plus similar new developments.

Modern intaglio prints include multiple colours and can also have washes on the surface of the plate to add texture and tone.

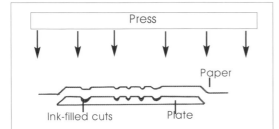

Intaglio press, showing the incised pattern in the plate. The damp paper is pressed down, pushing into the grooves to pick up the ink lying there. The ink does not fill the incisions or there would be blurred lines when the ink overflowed. Note the paper is wider than the bevelled edge of the plate so that an impression mark can be made.

The embossed lines can be felt clearly by running a finger over the front of the finished print, making it easy to distinguish an intaglio print from any other. The paper is also pushed down around the sides of the plate, sinking the entire image into the paper. This also leaves the unique plate-mark which is an undeniable pointer to an intaglio print. To accomplish all this, the intaglio press carries much more pressure than a relief press.
See PART FOUR.

Intaglio silicone rubber print
A modern technique for obtaining very large prints too big to go into any normal press. A silicon rubber cast transfers the image and the cast is printed by hand. Very useful for oversize murals and posters.

Intaglio fakery. Copy of a 19th century engraving in black and white. Reprints in books have no plate marks, so here an attempt has been made to fool the buyer.

The reproduction has been cut out of a book and pasted on to a heavier paper which has been blind embossed with a suitable plate mark.

The deception is obvious since the print, secured only at the corners, has come away from its support.

Valid when sold for decoration only, at an inexpensive price, this should not be confused with an original engraving.

Some old original prints are printed on very fine paper with a heavier plate-marked backing, but these will be solidly glued together.

Opposite
Intaglio techniques. Graham Ovenden: FLODDEN ALLOTMENT, etching and aquatint. These are often combined for the texture of aquatint with the fine detail of etching.

Japanese print c.1870, showing many of the characteristics which so impressed French artists working at the time.

The use of cut-off figures (the boat on the left) heavily influenced Degas and Matisse and gives a sense of a continuing reality beyond the painting.

The flat areas, together with the smooth blended colour achieved in Japan by brilliant craftsmanship in rolling inks together, inspired a whole range of new ideas in the West.

Japanese papers, Japan paper

Some of the finest hand-made papers for printmaking are Japanese. They contain very long fibres from barks as well as other indigenous ingredients and this makes them sustain the pressure of any printing press extremely well, no matter what their weight. Today the papers range from an almost luminous white down to deep cream and both pale and deep colours.

The older, traditional Japanese paper for mass market woodblock prints was thin

and very strong, hence the thousands of sheets which were used to wrap porcelain imported into the West. But nowadays their mills make a wider variety including heavier papers, some with organic flecks of grasses, flower petals, and many with marvellous textures.

In the UK, although French and Italian paper mills are often named, Japanese mills are seldom identified; in the US there is more knowledge of the individual products and the mill/type may be listed in the description.

Japanese prints
We owe a great deal to the flood of Japanese woodcuts which captured the imagination of the art world from the 1860s on. Their influence on painters such as Matisse and Toulouse-Lautrec was enormous, especially the flat areas of colour, decorative multiple patterns, and black keylines. The artists drew the images and fine craftsmen cut the blocks, both separately for colours and with colours dabbed on in small areas with tiny rollers.

Modern Japanese prints are just as intriguing although perhaps not as shocking to western eyes, running the full gamut from gentlewomen's portraits to huge, brilliantly coloured abstracts.

Jesus
French. Paper size 500x720mm (22x28in).

Jigsaw print
A wooden or metal block is cut up into its individually coloured parts. Each is inked with its appropriate colour and then the block is re-assembled and printed in one pass. A characteristic is the clear line of separation between the colours, without any overlapping. Also sometimes called a compound print.

Kallitype
A print technique using salts exposed to light to produce a brown or sepia print. Sometimes called a vandyke print.

Keyline
An outline of the parts of the image, often printed in black on top of the colour by the Japanese printmakers as well as western artists, which ties the entire composition together. Also used during the making of a print to act as a REGISTRATION guide.

Keyline. Detail from a modern Japanese print with keylines.

Kiss impression
Before a full relief print is made, a pull may be taken very lightly, using only the hand rubbed over the block, to check the overall composition. Of interest but of no monetary value to the collector unless the full print is extremely rare or there is some controversy over the method of production.

L

Lap marks

When ink has been unevenly rolled on to a plate, it can print the occasional line which is thicker than intended. This is a sign of poor quality control if it appears on an approved print. Other indications of poor inking practice include uneven lines along the edges, splodgy colours or grey areas in the middle of intense black, and one side of the print unintentionally lighter or darker than the other.

Lay marks

Marks around the image which will allow the printer to ensure registration is as perfect as possible. Generally visible only on trial proofs, although in Kento, a Japanese system for relief printing blocks, the registration lines are cut into the block margins and printed with the image.

Letterpress

Another name for direct relief printing, once used for everything including text and illustration in books, magazines and newspapers. Craft-oriented, it is no longer commercially viable and has been replaced by modern, off-set systems, but artist-owned and small presses, producing fine art books, still keep the presses going.

Light

The greatest threat to all works on paper, light fades the colours and weakens fibres to leave brittle, browning paper. Hanging prints is walking a tightrope between good light to see by and no light to protect the works. See CARE AND CONSERVATION for suggestions.

Light also means a thinner version of a typeface: e.g., Helvetica Light.

Limited edition

During the 20th century it has become more usual to publish original prints in limited editions. This is an agreed number that will be made available for sale, with no more being printed or reprinted.

Every sheet is signed by the artist or the authorising organisation and numbered (e.g., 4/150 is the fourth out of a total of 150). The number is on the left, the title in the middle, the signature or monogram and sometimes the date on the right. But this arrangement is only customary and may change with the individual artist.

Limited editions may not all be printed at once. Lack of orders may lead a to print on demand, although the copies will be numbered as for the full edition, e.g., 3 over 30, though only 10 are actually printed at the time. At the end of the print run the plate, stone or surface should be cleaned off, defaced or cancelled.

Unfortunately, "limited edition" can be misleading. A print recently offered bound into a well-known magazine was headlined as a limited edition, but they were not numbered and the signature was reproduced, which would not qualify in any accepted fine art context. And, of course, the run and the edition must have been well into the tens of thousands.

There are also accepted customs in the trade which the new collector may not understand. Contemporary prints may be offered in a number of editions, the same image in different colours. Colour change does create a new image. But purchasers may not realise, for example, that the

Andy Warhol "*Marilyn*" they are buying as one of an edition of 250, properly marked and signed, was also printed in nine other colour combinations – 2,500 Marilyns in all.

The paperwork accompanying a print should include the specific coloration as well as the image title, and you should ask if there are other colour and size variations of the same image.

Another acceptable variation is to print an image on different papers; very high quality for a small number of discriminating collectors, a reasonable number on medium quality paper, and a largish number on cheaper paper. It may also possibly have been used within an illustrated book, or offered in other sizes. These are properly called MULTIPLE EDITIONS.

However, this too can be misleading because the individual prints are given the number of that particular run (e.g., 4 out of the 5 on fine paper) without necessarily noting that there were another 100 or so on different papers. Records of the actual paper as well as any other use should be offered with the buyer's receipt.

Another more dubious numbering device is to take advantage of regional markets. Prints might be pulled in double editions, perhaps inconspicuously marked A.P (American proofs) or E.P (English proofs), but each numbered 1-50. A buyer might well assume the A.P meant Artist's Proof and the E.P stood for the French equivalent, *epreuve d'artiste*.

A recorded example of this particular ploy was a complete edition of a Dali print;

Limited editions. In spite of appearances, not all artist's prints are limited editions. This is a Picasso lithograph, signed and dated (but not numbered).

Such unlimited editions offer opportunities to the new collector for enjoyment, usually at a lower cost, depending on the rarity value and how many examples are still around.

It's a good way to discover whether an artist's work is something you want to own, or grow tired of quite quickly. It can back up your collection of limited edition prints, too, as you see how the ideas and concepts of an artist develop.

L

Albert Irvin RA: LOUISE I, *screenprint, 2002*
edition size 80
Signed, numbered, titled and dated verso
printed and published by Advanced
Graphics, London.

Right
Basic information about a print that should
be given when purchasing. Some print
publishers will offer even more, such as
the exact colour sequence and the names
of the printing team.

See BUYER'S CHECKLIST for detailed list
of best practice in what to record yourself.

Artist
Title
Type of print
Paper
Size of image, and size of sheet
Date
Number of print, number total in edition
HC (proofs, reference copies, etc)
Printer
Publisher
History if known
Price

these, eagerly sought by novice collectors, were published in American and French editions. Buyers believed they each had one of 300 instead of the true count, one of 600. It may not actually affect the value very much as long as the total is not excessive, but knowing what you are buying is surely essential.

Learning something about the various printing mediums can also help. The plate for drypoint etchings, for example, can only be used for a very limited number of prints before the burr wears away, so that if you are offered a drypoint etching numbered 125/150 it is cause for alarm. Most only reach 10-12. There is more specific information about print mediums and what to look for in PART FOUR, Printmaking techniques.

If you are concerned to buy only small editions, as some dealers suggest, note that even with a limited edition of 30 there will probably be at least another 10-12 prints made for the artist, the printer's records, the publisher's archive, etc. See under PROOFS. A proper document will list all the proofs printed at the same time as the limited edition.

Do remember that most misrepresentation is due to ignorance rather than trickery. Reputable publishers and dealers go out of their way to be as open as possible about everything they know; all that is needed is to ask the right questions. What they do not know they should be able to find out and thus reassure the buyer.

Every purchaser of a limited edition print should receive a label/invoice that includes fundamental information.

In the past young artists working on their own with limited resources may have believed that such meticulous paperwork was unnecessary, but now all art schools and advisers understand how important it is to gain the trust and confidence of the casual buyer as well as the dedicated collector. See illustration below.

Limp binding
Softback cover on book or magazine.

Limited edition. A young artist attempting an etching in the style of the wood engravers of the Bewick school.

This is marked 1/4, so will obviously be a rare image, if the artist becomes famous. That's part of the fun in buying at Degree Shows. Meanwhile it's a delightful and skilful bird portrait.

But do make sure the print is properly signed – this example was not, but the artist was there and signed on the back.

L

Line

As in line block, line engraving, lineart – all words reflecting the use of drawing in line as opposed to tone. See right.

Linocut

Shortened form of linoleum cut in general use. Linoleum is a kind of floor covering made of oil on a canvas base. It has proved an attractive medium for artists almost since its development.

The soft surface is far easier to work than wood, but it needs a firm base, so a square of linoleum is tacked on to a wood block for cutting or engraving. See PART FOUR for history and techniques.

A major factor in the popularity of linocuts among students is the inexpensive material, so that even young artists in primary school can enjoy making prints on a reasonable budget.

Lithography

Taken from the Greek words *lithos* (stone) and *graph* (drawing). It is one of the PLANOGRAPHIC techniques of printmaking, as the surface is flat, neither raised as in relief, nor cut as in intaglio.

Lithography was developed c.1798 by Aloys Senefelder in Bavaria to help him reproduce music notation. It exploits the fact that grease and water do not mix. A great attraction is that the drawing can be as free as drawing on paper.

The addition of colour in the 1860s transformed the medium, which became, and is now, one of the most preferred for painterly printmaking. See PART FOUR.

Line. Stems and fern leaves in line.

Linocut. FLYING BIRD *by Henri Matisse shows the simplicity of sharp cutting.*

Opposite
Linocut. Trevor Frankland: VENETIAN INTERIOR. *A far more complex print with the details incised by dental tools instead of the customary knives.*

Lithograph

A print made by the lithographic process. Lithographs, with their unrivalled ability to reflect the artist's spontaneity and the brushwork of the painter, make up a good percentage of prints available for collectors. No other form of printmaking shows as much variety, so appreciating the best of the craft is very useful.

These three examples show some of its versatility. See PART FOUR for more detailed information.

In addition, until the development of screenprinting for artists c.1939, lithography was the only medium that could easily be made in large sizes, for posters and wall panels such as those made by Lautrec, Bonnard and others.

Posters are a specialised field in printmaking and collectors need to be particularly careful about condition, for obvious reasons, and there are many photographic reprints. See BIBLIOGRAPHY for suggested reading.

Opposite, far left
Georges Braque: FIGURE, lithograph. Its
loosely elegant outlines combine with vivid
colours and background texture, the curled
hair indicated with big, fat brushstrokes. At
the same time the lines of the eyes and hair
are as delicate, smooth and fluent as they
would be on a drawing or painting.

Above centre
Tom Robb: REGATTA, lithograph 1959. The
simple shapes of the white sails could almost
come from a wood or linocut, but the
painter's free brushstrokes of the water are
purely lithographic. Today lithography is often
used as a base for mixed media prints, with
collage, small areas of etching or aquatint,
etc.

Above right
Jorge Camacho, lithograph. This Cuban
lithographer has a very different style based on
line. The caricatured faces have been drawn
freehand, not cut into a surface, so that the
continuous, fluid line and the painterly blobs of
red pigment are equally expressive.

This print has faded badly on the right from
exposure to light. The paper has browned,
although it is acid-free.

M

Maculature
French. When a sheet is printed on an intaglio press, there is a residue of ink left on the plate. Sometimes, instead of wiping the plate clean with a cloth, a second impression, the maculature, will be printed on a fresh sheet of paper. This cleans the plate, preventing an unwanted build-up on the surface. The maculature can be quite pale or almost as good as the first print, depending on the image and the amount of inking that is required. Occasionally the maculature will be offered later for sale as a working proof.

Manière noire
French: mezzotint.

Margin
All the plain, unprinted paper around a printed image. Edge to edge prints do not have a margin.

Masking tape
A light, low-tack paper tape which has many acceptable uses in print-making, but is often used foolishly by unwary collectors to hold a print in its mount. *Never* use masking tape instead of purpose-made, acid-free hinges. This can result in serious damage to the paper. The tape, although easy to pull off for a while, eventually becomes dried out, the glue becomes dark and sticky and is impossible to remove. See FRAMING, p.122.

Master proof
Another term for the BAT. Also a single proof kept by the printer which holds all the corrections made by the artist and any technicians involved in the printing.

Matrix
Any printing surface which holds the image to be printed.

Mat, matt
Dull finish. Matt in the UK, mat in the US.

Medium
In art a binder which holds the various kinds of pigment in a state ready to use, and thus by extension the various kinds of painting – oil paint, watercolour, ink, etc.

In printmaking the individual technique which is used – intaglio, relief, or plano-graphic and/or specifically the etching medium, engraving medium, etc.

Mezzotint
A kind of engraving where the entire plate is stippled with a special rocking tool so that if rolled up with ink it would print completely black. The image is created by burnishing or rubbing away the stipple so that these areas will print from a slightly lighter tone (with just a little less stippling) to pure white with no stippling at all. The result is an intaglio print with a velvety rich black which cannot be produced in any other way.

Although first invented in the mid-16th century, mezzotints are still popular today either over the entire print such as the one illustrated opposite or for areas within a mixed method print.

The technique requires very careful crafts-manship of a high order, so that artists sometimes leave the first overall use of the rocker to the technician and concentrate

on the image, The line is so rich that charcoal drawings are sometimes confused with mezzotint prints, but if you look closely under a glass there will be a faint shadow of the stipples on the paler tones, whereas a charcoal drawing will show only the clear paper.

Mezzotinta
Italian: mezzotint.

*Mezzotint. Vincent Boczarski: NIGHT
The artist has used the soft rich black of the medium to create an unforgettable contrast in this print.*

Mixed media print, Mixed method print
Both these terms are used nowadays and refer to two or three different print techniques in the same print. This has become more and more common – screenprint and etching, lithography with relief, etc.

A fairly new idea is the use of many many more techniques in one print. This has been notable with the evolution of master printer/studios which work closely with the artist. This teamwork has allowed artists without all the necessary technical expertise to try new concepts and experiment with pushing out the boundaries of each technology.

M

One American printer recorded lithography, woodcut, etching, linoblock and metal foil engraving, using 26 colours and two different papers, all on one print in an edition of 25. A mixed media print like this requires considerable skill in the studio; they listed seven technicians in their print book for that one single project.

Monochrome

Any print in a single colour. Most commonly in black but by no means always.

Monoprint

This and the following term are often confused by new collectors. A monoprint is either one or one of several pulls taken from the same image, but each time with differences in colour, or paper. The matrix remains constant. Any medium may be used in both monoprints or monotypes.

Monotype

When a print is pulled once and the matrix is then re-worked or changed, the print becomes a monotype – a unique work. The artist is using printmaking not because it can be replicated but as an art medium in its own right, like watercolour or oil, for its particular qualities.

There was also a well-known typography factory which used this as its trade name.

Monochrome. TURTLE, a monochrome etching by David Wurtzel in ochre.

54/75 David Wurd

Monoprint. Phillida Kent: TRY ME AND SEE

M

Moulded papers

In recent decades papermaking has become an active art, not merely providing the surface on which a print is made.

Cooperative printmaking has inspired artists and printers to work with handmade paper manufacturers in producing papers for special orders. These may even take three-dimensional form as paper objects, coloured as required, and shaped according to the needs of the artwork. Some papers are so uniquely crafted for the purpose that they are editioned in the same way as the final print. Visiting a hand-made paper mill is an instructive experience for any collector.

Mouldmade paper

Paper made on a cylinder machine, which uses a roller to pick up the pulp and lay it down in a continuous sheet. Unlike hand-made paper, which is made sheet by sheet with four naturally deckled edges, the mouldmade paper has only two deckled sides; the remaining two are torn off according to the size required.

The torn edges and a light mesh pattern from the cylinder on the reverse identify the type of paper immediately.

The pulp is of high quality and mouldmade is the standard choice of many printmakers. See HAND-MADE PAPER.

Mouldside

The reverse of mouldmade paper shows a slight patterning from the mesh cylinder.

Multiple editions

When an original print is published on several different kinds of paper it is called a multiple limited edition. The intention is to provide a range of less expensive prints on good paper and fewer, more expensive copies, on the best paper.

This has been good practice for centuries, and many of our finest original prints, such as those of Picasso published as *The Vollard Suite*, were issued in two or sometimes more grades of paper.

Multiple editions are based on the exact same image being printed. These do not include images which have been changed by new colours, etc. But for the buyer the same queries should be made.

A good publisher, dealer or gallery will always put down the details of the edition on the paperwork which comes with any purchase, but this sensible practice is not always followed by the less reputable sales people, especially when they are dealing by mail order or the internet.

Irresponsible sales people may hope that the collector will ignore details about the exact paper, but very few are prepared to commit themselves in writing and will probably give the correct information if requested, or most likely plead ignorance. That at least means that there is some research to be done by you.

If you see another copy of a print for sale at a very different price level, always check that the size of the image, as well as the size of the paper, the paper itself and the size of the edition are the same.

30/30 Margaret Knott

Multiple print

A single sheet with more than one print on it, often used for very small images which would otherwise become lost in the middle of a sheet, or for a group of related images.

A repeated image may also make a stronger visual impact – see FRAMING, p.124.

Multiples

Three-dimensional printed objects, made usually in a very small edition.

Above
Multiple print. Margaret Knott: FIVE TULIPS. The tulips in grey are carborundum prints.

Right
One of the single tulip prints which were used to make up the top print.

Nacre

A pearly finish. This can be found in inks or laid on to wet ink after printing. Some Japanese papers are known for their pearlescent surface.

Nature print

A product of the interest in natural forms, grasses or thin-leaved plants can be pressed into soft lead plates, to be inked and printed, or, by double electrotyping, be turned into a relief and again inked and printed as usual.

Neutral PH

PH is the measure of acidity. It is vital that any substance in contact with a print has a pH of 7 or above to protect it. See ACID-FREE, ARCHIVAL PAPER/BOARDS, and CARE AND CONSERVATION, p.116.

Newsprint

Cheap paper supplied in large rolls and used for very early proofs. It will not survive very long without turning brown and brittle so these early proofs have little value except for study. Also used for blotting up excess ink before editioning.

Numbering

All the prints sold in a limited edition are numbered, the number of an individual print above, the total to be published below. Traditionally numbering is done in pencil, because the damp paper of the fresh print might cause ink to bleed.

Any limited edition should be numbered and signed individually, no matter how small or large the edition.

Oleograph

A colour lithograph printed on to paper impressed with a canvas texture and then varnished to simulate an oil painting. Originally 19th century, but still in use today.

Original print

A term finally becoming accepted in the 1960s to distinguish those prints where the artist has intended to create a work of art using printmaking techniques, rather than a print which is a photographic reproduction of a work of art in another medium. It is also considered important that the artist is involved in the work, either by himself or herself or with the help of technicians. See p.12 for detailed information about what constitutes an original print.

Over-etching

A fault in the printing process where there has been too strong an acid or the plate has been too long in the acid bath. The result may be loss of subtlety in the variation between thin and heavy lines.

Over-inking

Using too much ink on the plate, or ink which is too heavy for the kind of press. In intaglio prints these will both result in squashy lines where the ink spills over the edges, and/or in-filling small areas of cross-hatching or parallel lines.

In relief printing over-inking blurs the edges of the surface so that they lose crispness, or it bulges out over the edge to make irregular lines around the block.

Under-inking engraving; the ink was wiped over the wood but failed to fill either the grain (this was not intentional as it was on p.68) or even the cut line.

When too much ink is poured, the line will fill in. The clumsy cutting shows the student had trouble controlling the knife as well as the inking.

Pagination

The numbering of pages in a book – see FOLIO. Although folios may be left blank in an art book to avoid visual conflict with an illustration, they will be counted in the pagination of the book.

Palladium print

Photographic print using palladium which gives a brownish tone.

Paper grips

Rectangular pieces of clean paper which protect the print from inky fingers during printing.

If putting on white gloves is too much bother when handling unframed prints, paper grips can be used when taking them out from their sleeves or portfolios.

Paper surfaces

Western cartridge papers are available in three surfaces; HP, or HOT PRESS, which is glazed and smooth, NOT, which is cold pressed, retaining its natural but slightly uneven surface, and ROUGH, with the most irregular surface. HP is the best for most prints as too irregular a surface will not pick up ink properly.

Oriental papers do not use this distinction but are described by printers by the manufacturer's name, or texture and weight, and with any identifying notes about colour; e.g., off-white Kasurai paper.

Papyrus

Early form of paper made from Egyptian reeds, still made and used for its special texture today.

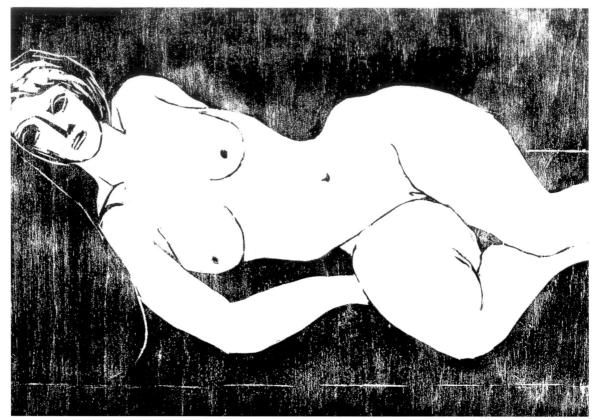

Above
Plank. Harald Kihle: NUDE

Left
Plank. Edward Gordon Craig: IPHIGENEIA

Both woodcuts are worked on a block from the plank and show the artistic use of the texture of natural graining.

Although the plank is hard to cut in curves across the grain, so that intricate detail is difficult, the texture is its own asset and has been exploited by artists from Gauguin onwards. It can be increased by abrasives used to bring up the patterns.

It is said that Gauguin made the first grained woodcuts because in Tahiti he had no highly finished planks and used rough-cut sides of packing cases. Whether this is true or not, it is a happy accident which has been much admired and copied by artists everywhere.

Parchment
Animal skin used in medieval times for court rolls, etc. It can be dampened to print relief or intaglio; the faint mottling is still attractive to printmakers.

Platinum print
Photograph using platinum instead of silver; palladium and platinum prints are often part of a mixed media print.

Photo-etching, Photo-lithography
Photo-relief, Photo-screen
Any print using one of the above methods which includes a photographic element. Very common in combination or mixed media prints.

Photogram
Printing by placing objects on photographic paper left in the sun or in light. Revived in the 1920s-30s.

Photogravure
A confusing term, originally the indirect process by which mass printing was achieved for magazines, newspapers, etc., but now occasionally used to refer to half-tone photographic images.

Pigment-based inks
Computer inks of the past were based on dyes but their fastness was questionable. Modern pigment-based inks offer acceptable levels of fastness for archival and other purposes – in some cases up to 100 years or more. See PART FOUR, Digital papers and inks.

Plank
The block of wood cut from along the grain for woodcuts. See opposite.

Planography, Planographic
The various print methods which are printed from a flat matrix, such as lithography, screenprinting, etc.

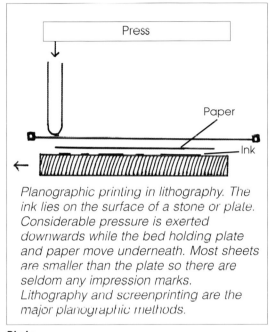

Planographic printing in lithography. The ink lies on the surface of a stone or plate. Considerable pressure is exerted downwards while the bed holding plate and paper move underneath. Most sheets are smaller than the plate so there are seldom any impression marks. Lithography and screenprinting are the major planographic methods.

Plate
Any flat printing surface, thinner than a block or a stone.

Platemark
The faint impression left around the image when printing intaglio and when the paper is larger than the plate.

Pochoir
French: stencil. Method of dabbing ink through a stencil. See DAB PRINT

Portfolios
An ARTIST'S PORTFOLIO is a selection of his work. Actual portfolios can be bought in art stores, made from cheap card to the finest leather. For carrying or storing prints the interior must be acid-free.

Pressure gap
Space between the print and the glass. If they touch the print may become damaged. See FRAMING, PART THREE.

Print book
Every printer should keep a careful record of all editions, usually called the Print Book, and that information should be available to the collector. Insurance companies will be much happier about valuation when they have details, and the collector can learn not only about what is in the collection but what might be interesting to find in future purchases.

Print cabinet
Traditional name for a collection of prints at home or in a museum. Now largely obsolete, but it does crop up in catalogues sometimes: "was in the print cabinet of…".

Printer's proof (PP)
Any one of the proofs taken as a working proof to monitor changes, or as a final proof before editioning, and kept by the printer for reference.

Printer's stamp
See CHOPMARK

Progressive proofs, PP
Proofs showing the correct order of colour printing; usually kept for reference, and essential if the edition is not being completed at one time.

Proof
Any pull taken from the press before editioning.

Proofing
Proofing is the process of testing before the final printing of any edition. The proofs themselves are the result, i.e. those sheets not yet approved for editioning, but which enable the printer and the artist to judge how the progressive steps are being achieved.

The individual tests have their own names or commonly-used initials which are often marked on the sheet. See ARTIST'S PROOFS, TRIAL PROOFS, PROGRESSIVE PROOFS, COLOUR PROOFS, STATES, BAT (RTP) PROOFS, PRINTER'S PROOF, EDITION PROOF.

Proofing paper
Usually a cheaper paper for the first proofings. While the woodblock, plate, stone or screen is being prepared and inked, rolls of cheap newsprint are used; not good enough for fine-tuning, they will be accurate enough to adjust position in the press, flow of ink, registration, etc. When colour proofs are started, the edition paper should be used since it will have a considerable effect on the colour and saturation of the inks.

Opposite
Trial proof. Henry Moore: FIVE FIGURES, *lithograph*

Even though neither signed nor numbered, the artist is unmistakable; in this case the provenance direct from the artist gives the stamp of authenticity.

The registration mark is clearly visible at the bottom. Moore noted the green was re-mixed for him a number of times until he was happy with the result, and the various trial proofs show the intensity of the colour changing considerably.

Above
Provenance. Robert Kaufman: ZANESVILLE, OHIO. *Keeping notes of when a print is acquired can make establishing a provenance easy and quick. This was bought from the artist's father some thirty years ago, which is proof enough.*

Right
Provenance. Michael Ayrton? *This, on the other hand, is neither signed, nor numbered, nor does it have any record in the files.*

Relying solely on a faint memory of a casual gift from a friend at art school, accurate authentication will have to wait for laborious research into the artist's work and possible source of this image. An example of carelessness which ends up causing a great deal of trouble.

Provenance

The history of a print, absolutely vital with any art collection. Provenance ideally traces the print from its first editioning through its various owners to confirm authenticity.

Having all that information ready will make it easy and quick to get an accurate valuation and cataloguing for any future sale. See CHECKLIST FOR INSURANCE, p.110.

It may seem obvious that expensive and important prints should be carefully recorded, but every purchase should have its file, no matter how slight, or how sure you are that memory will suffice. This is partly because the future reputation of any artist is hard to assess, but also for one's own satisfaction. The two prints on the left are examples of good and bad practice.

Publisher's proof

An extra print taken from the edition run which is set aside for the publisher's records. Obviously there are occasions when the printer and the publisher are the same, and these prints will usually be marked PP.

Pull

A single impression taken at any stage before the editioning; as soon as editioning starts, a "pull" turns into a print.

Registration
Detail of the edge of a poorly-registered print, where the paper has slipped when laid over the second plate.

You can see the first printing underneath at the bottom of the picture.

Reduction, Reduced print, Elimination print, Suicide print

All these terms are used to describe a way of making an image by starting with the first colour, printing the entire edition, then changing the matrix for the second colour, printing the entire edition again over the first, changing the matrix again, printing the third colour, and so on. A characteristic is the layering of colour, the lightest underneath and the darkest on the top. It is referred to as a suicide print because it will never be possible to print from the original matrix again.

Register, Registration marks

See LAY MARKS and below. Some proofs show the registration marks quite clearly, but these are cleaned off before editioning.

Registration

A vital skill in the sequence of printing. Printers and artists have adapted many ideas to make sure that, when the paper is put through the press more than once, for whatever reason, it lies exactly in the same position as during the original printing. The plate may have marks, pins, needles, t-square bars, anything in fact which the printer finds works for them. Poor registration can be easily seen when colours slip over a marked area, or lines do not match up.

Relief etching

Etching is generally an intaglio method, but it was possibly William Blake who tried drawing in an acid-resist liquid on a clean copper plate so that, when immersed in acid, the *background* was bitten away and the lines of the image were left standing above the surface. The plate was then printed as a relief. Unusual.

Relief printing. Tom Chadwick: FAN DANCE, *woodcut. See relief press, opposite.*

Relief printing

Any form of printing where the image is higher than its background and only the raised surface is inked and printed. Relief presses have a relatively light pressure, and relief prints can be made by hand very successfully. The most common relief printing is done from wood or lino, but almost any flat surface that can be carved out will do – even potato.
See RELIEF PRINTING, p.136.

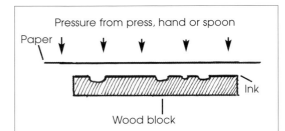

Relief printing. The image is always above the background; note the paper extends over the block but does not become marked as the pressure of the press coming down is too light.

Relief prints can also be made without a press by rubbing or burnishing the back of the paper which can become slightly shiny.

Reproduction

Any copying, usually from another medium such as oil painting or watercolour, by photographic or other means; not an original print. Buying a fine reproduction of an admired painting is only foolish if the collector overestimates its commercial resale value.

Most popular reproductions are unlikely to prove an investment until generations have left only a few in circulation. Some, of course, do achieve that status. Old film or exhibition posters, for example, if they are full size and from the original issue, were printed in relatively small numbers. These seldom remain in decent condition, so any that are still in one piece and not too badly faded do have a genuine market.

The collector who is serious about buying for investment would be sensible to restrict purchases to original prints and to limited editions.

Restrike

Another word for a reprint. Restrikes of well-known modern artists pretending to be original limited editions are made illegally. These often come on to the market after the death of the artist when they have a better chance of success.

Reverse image

Images made on a traditional press will be reversed when the paper is lifted up. While reverse imagery is not too difficult to imagine, text can be tricky to write back-wards, so these days a great deal of lettering is put on photographically.

Print

Plate

RTP

Right to Print. See Bat proof

Run

The extent of an edition. Early prints, even up to the end of the 19th century, were seldom limited or numbered.

Today a short run would be anything from 1 to 18. A medium run would be up to 60 or 75, which for some unknown reason is a very popular number. Anything over that, up to 250 or 300, would be considered a very long run. Few original prints go beyond that.

Sand grain etching

A form of aquatint, where a sheet of sand-paper is pressed into a soft ground to create a texture similar to aquatint. The result is not as deep or rich in tone. Through a glass the texture will be far more regular than the scattered resin of a true aquatint.

Screenprint/Silkscreen

The screenprint is made using a screen or mesh, the colour being pushed through to the paper below. Stencilled shapes or liquid substances are used to block out the ink where required. The original screens were made of silk, hence its other name. A highly flexible process which can print on

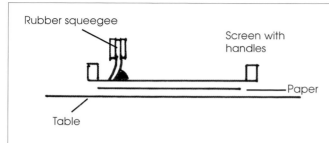

Rubber squeegee

Screen with handles

Paper

Table

Screenprinting is planographic; the flat table holds the paper and the screen sitting on top of it. The screen may be a metal mesh, nylon or, as it was originally, silk.

The rubber squeegee moves across the image, pushing ink into every part of the mesh which has not been stopped, or blocked up, by stencils or varnish.

Each colour has a separate screen and it can be washed and re-used or thrown away. Registration marks keep the paper in the right position no matter how many colours are printed on top. The result is flat, with no impression marks, and the image often has relatively hard edges compared with the brushwork of lithography.

to any surface, it has become extremely commercial. But, since the 1960s, the influence of Andy Warhol and Roy Lichtenstein has brought out its true potential. There are many individual printers, especially in the UK and the US, who have contributed enormous technical expertise and have helped to establish the medium. See PART FOUR for more history and techniques.

Serigraph
US mainly, an artist's original screenprint, used to differentiate between commercial printing and fine art. *Seri* is from the Latin for silk, *graph* from drawing.

Silkscreen
The original term used for what is now called screenprinting, from the use of silk as the screen, now superseded by synthetic material or a fine wire mesh.

Signature
The artist making a limited edition should sign every acceptable copy. Whistler

Opposite
Screenprint. Brian Rice: SECTOR, 1965

began the custom of signing in pencil, perhaps because pencil is harder to erase without disturbing the fibres of the paper, but perhaps because the damp paper of a fresh print might cause ink to bleed.

However, some artists do sign part of an unlimited edition, so research must be carried out if there is a signature but no number. It could be a one-off, or a fake with a newly-created signature. If an artist has made original prints which are bound into a book, then the book should be signed and numbered too, either next to the COLOPHON or on the title page. If there is more than one artist involved then the signature may be left out.

Size
A print can be measured by the image itself and by the entire sheet including the margins.

Slip sheet
A loose sheet of transparent, acid-free paper, usually glassine, kept between prints for protection or slipped between the pages of a book, and then often bound into the spine for extra security.

S

Soft ground etchings

When a soft, sticky coating is used as the resist, many gentler, softer textures can be created. The lines will have the appearance of charcoal or soft pencil rather than the hard crisp lines of ordinary etching. Other overall textures can be created by pressing material into the ground. Used especially for the creation of drawn prints, but also added to mixed media prints.

Solander box

A special acid-free box for the storage of prints and other works on paper. It opens from the side so that the prints can be slipped out. Available at most fine art supply stores.

Spot etching

The rise of multi-media prints means that areas within the print may utilise different methods. Small areas of etching may be added to a lithograph, etc.

Squash

Term used to indicate the build-up of ink on intaglio printings which creates a thicker ring around the printed line. Usually considered a fault of over-inking, but it may be deliberate.

State, State proof

An artist's working proof which may show ideas and even sketches, colours or comments as the image changes and develops. The proofs are sometimes marked as first state, second state, and so on. One of Degas' most famous prints, *Sortie du Bain*, was said to have 18 states, each one with so many changes that there were 43 different impressions, some with extremely subtle changes. States of well-known prints are intriguing for their help in understanding how a print developed as a work of art.

State proofs are generally the property of the artist and seldom available for sale, but they are sought by museums and serious collectors.

Sometimes states are confused with Trial proofs which serve the same purpose for the technical aspect of print-making, colour, registration, etc.

Steel engraving

It was discovered early in the 19th century that a steel plate would take the pressure of a printing press more reliably and for longer than copper. Today Steel facing is added to many other metal plates for the same reason.

Steel facing

See above, but the drawback with such a facing is that if the plate has to be corrected the steel facing has to be removed and then replaced when the alterations are finished.

Suicide print

See Reduction print

Surface printing

Sometimes used instead of relief.

Opposite
State proofs. Brian Rice: NOVEMBER
This screenprint went through a number of changes until the artist was satisfied with the final image, bottom.

1/50 'November' Brian Rice 1965

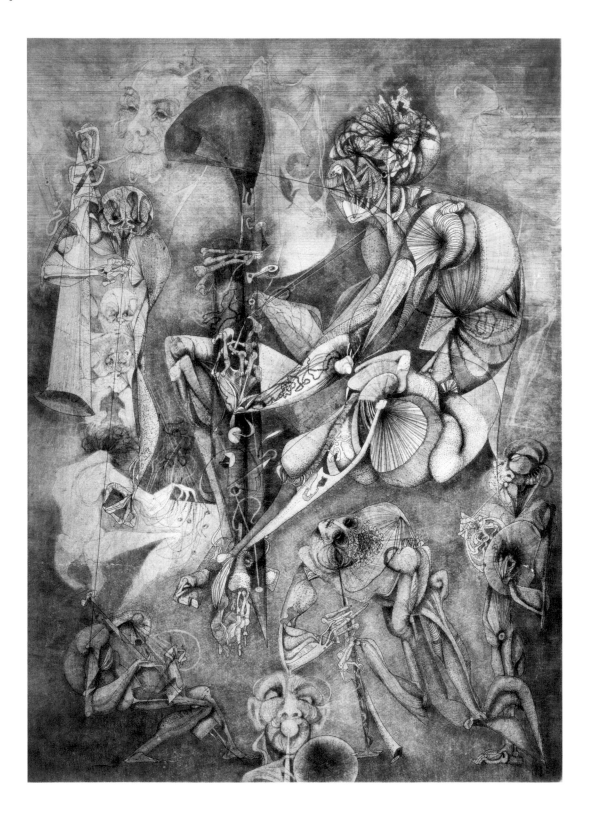

TMP

Tamarind Master Printer is a professional qualification in fine lithography from the American Tamarind Institute. Widely recognised, it guarantees the quality in the making of any print and may be mentioned in the history accompanying a lithograph. See COLLABORATIVE PRINTMAKING for mention of other American, English and French fine art printers who have become world famous for their innovations of technical skills, especially in screenprinting and lithography.

Tip, Tipped in

When original prints are included in a book they are sometimes printed separately and tipped in by having a strip of acid-free glue along one side which attaches the print to a backing paper.

Opposite
Karl Demul: SIREN, *etching. A trial proof considered too dark by the printer.*

Tint, Tinted

Monochrome prints were often coloured by pale washes, either by hand or by stencil. This was tinting. Tint is also used to mean a pale colour.

Tone

The darkness and lightness of any colour. Each method of printing has its own way of creating tone. In general terms woodcuts may use three different blocks and print them in light, medium and dark tones; intaglio prints use stippling or cross-hatching and resist spattering in various techniques to create denser and lighter areas, and lithographs and screenprints use the colour in darker or lighter tones for the desired effect. These may also use photographic methods such as a half-tone screen or a clear film technique.

Transfer lithograph

When the artist draws the image first on paper or film, this can be transferred to the plate, with or without photography.

Trial proof

Proofing trials to check registration, colours, inks, or any element in the print which might need changing by the printer. When the artist changes the image itself, that is usually called a STATE PROOF, which see.

Trimming

Cutting down the margin of a print used to be acceptable, especially when it was to be framed. Today the margin, or the deliberate lack of it, is considered part of the image, and trimming may lower the value considerably.

Unique impression

Any print which could not be reprinted in the exact same form is unique. A proof could be unique, or a trial that did not meet the artist's approval and was discarded, or, of course, a monoprint or a monotype.

Unlimited edition

Any print which is published in an unrestricted run, usually as long as there are sales for the image. There will be no number, although sometimes there are some signed copies for special sale. See EDITION and LIMITED EDITION

Unpublished

A matrix, either a plate or a block, etc. which has never been issued as a print. These are sometimes found in the studio of an artist after death, or as part of a printer's stock if the print was intended for publication at a future date.

Vellum

Made from young animals, the skin is not split but simply scrubbed and scraped to make a clean surface. Still used occasionally for special effects.

Verso

The reverse of a page or printed sheet.

Viscosity printing

A technique devised by S.W. Hayter based on the theory that inks with different viscosities will not mix.

Washi

A generic term for all Japanese papers.

Water burn

A fault in the cleaning away of water on the lithographic stone which can result in streaks and blotches on the print.

Waterleaf

A very popular paper because it has no size or coating. It is extremely absorbent but becomes very fragile when damp and must be handled with great care.

Watermark

The logo of the paper manufacturer is included in many papers and can be seen if the paper is held up to the light. Some special printings are made with paper carrying a logo or even the signature of the artist and/or the publisher.

White line engraving

Most wood engravings are black line on a white ground, but this can be reversed, with the background surface left high and then inked and the engraved lines left clear to print white on black.

Woodblock

Used for both the wood which is used to make woodcuts, but also adapted by the West to mean the traditional Oriental prints which we would otherwise call woodcuts.

Woodcut

A relief print cut with knives and gouges out of a plank. Only the raised image is inked and printed. The strong contrasts and relatively simple lines give the medium its unique appeal.

Woodcut. Robert Gibbings: SITTING OUT. *This delightful scene has caught the stiff formality of the 1920s-30s; the figures reflect the best use of the technique in its strong outlines, sharp black and white contrast. Compare with the more fluid lines of wood engraving on the next page.*

Above
Wood engraving. Claire Leighton: LAMBING IN JANUARY, 1937, *during the great revival of wood engraving in the US and UK.*

Left
Wood engraving. Brian Rice: DOWTH

Many are black and white or in classical monochromes, but woodcuts can be coloured either directly on the block or with individual blocks made for each colour.

Since Gauguin many artists use the grain as part of the image. See JAPANESE PRINTS, and PART FOUR, for history and technique.

Wood engraving

Using the end of the block, the wood is much harder than the wood cut from the plank for woodcuts, and can take fine engraving with tools similar to those used for metal engraving, i.e., gravures, knives, etc. This is one of the finest traditional mediums.

Thomas Bewick developed English wood engraving by adapting the tools of metal engraving to their use on hard wood. His meticulous, miniature style, with small vignettes of natural subjects, has set the standard of the craft ever since.

Modern wood engraving began a new resurgence in popularity at the beginning of the 20th century and has continued to be dominated by relatively small scale subjects of incredible detail.

John Nash was only one practitioner, but still one of the finest, and now some much more contemporary images are emerging. See PART FOUR for the history and technical description of the medium.

Working proof
Another synonym for TRIAL PROOF.

Xerography
A trade name which has become synonymous with office copying machines, but has been used by some artists in the creation of collages or multi-media prints.

Xuan paper
A Chinese paper much in use for printmaking, and extremely absorbent.

Xylography
A synonym for woodcutting or engraving.

Zincography
Lithography using a zinc plate instead of a lithographic stone.

86

PART TWO:

STARTING TO COLLECT

GETTING STARTED

Just as with any new endeavour, when you start to buy prints as a personal collector there is a wild combination of excitement and common sense caution.

In the case of art there are primary questions, too, about, first, enjoying and appreciating what you are looking at and, second, developing judgement about what is worth buying.

Even for the financial investor, it is widely accepted that enjoyment should be the foundation of any purchase. Markets come and go with astonishingly rapid highs and lows and fashions reign in the art world as in any other field. But, if you buy prints because you love seeing them on the wall in your room, or are delighted to have them available any time you choose to look in a portfolio, that will not change with the uncertain weather of fame. This holds true no matter how you begin collecting.

It may begin with an impulsive purchase, a single print or an artist whose work touches the heart and practically forces you to buy! Then a recognition of how much pleasure this brings with it can encourage a more measured attitude towards finding out more about the printmaker, about the subject, the person, the style, its history…

Or perhaps collecting begins before a single purchase, when a book, a visit to a gallery or a museum triggers a similar decision to learn more, to explore this very affordable art form, to discover the range and quality of printmaking in all its variety. If you are this more methodical person then you will look and read and look and look again before you begin to collect.

First thoughts

But no matter how it begins, the same process should give a sound basis for acquiring prints which will please both eye and heart; start by thinking carefully about what you find most interesting and perhaps challenging, too, in the art world. A subject, a period, a medium, a particular artist, or even colours – a world-famous collection of paintings was formed because the owners loved bright colours! Think about work you have seen and liked, but also about ideas you might not have understood but would like to know about – surrealism, abstraction, etc.

There are printmakers who worked in every period and in every style and sometimes these concepts are easier to understand in the relatively small scale of a print than in an overwhelming collection of huge paintings.

This preliminary programme for yourself can start with the cooperation of staff in galleries, auction houses or museums. Ask them about any of these starting points, and also see specialised books in print in the BIBLIOGRAPHY, p.186.

Opposite
Starting to collect: a lithograph (no title) by Alexander Calder, only one of the many well-known artists whose prints are far more accessible and affordable than their other work.

Collecting by special subject:

Above
Clifford Hatts: TIGER, *lino cut*

Right
Jane Levenson: COCKEREL, *lithograph*

Both these and the turtle etching on p.62 were made for children's books, but they could be part of a collection of animal prints.

Very different in technique and style, they are united by the subject and could be framed in the same way.

Perhaps even better would be a group of animal prints in the same medium – etchings, linocuts or lithographs.

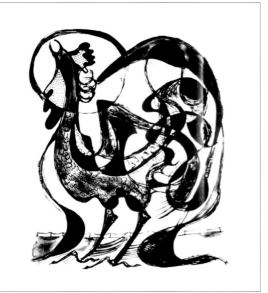

An important factor is that these preliminary excursions can take you into new directions that might not have been obvious. For example, if flowers are a favourite, then classical botanical prints are clearly a source of pleasure, but there are also beautifully precise wood engravings which deserve attention.

If drawing is your preferred medium, then etchings like those of Alistair Grant in black and white (p.95) come to mind immediately, but there are many early lithographs by Matisse and others which should also be considered.

Addicted to bright colours? Screenprints should be a first call, but 1950s and '60s lithographs were often printed with knock-out brilliance.

If the sinuous line of the art nouveau style is what attracts you, then you might well enjoy the many ARTISTS' BOOKS which were published at the turn of the century and up to the 1920s. Or if you decide you are fascinated by the intricate story-telling detail of Hungarian illustrations, you may be led to János Kass' modern prints and posters so popular in the United states.

And if you are absolutely entranced by the technique of printmaking then some COLLABORATIVE PRINTS from American print studios might hold enough mysteries to keep you riveted for weeks.

Second thoughts
From any of these starting points, the novice collector will find more and more possibilities, But that too has its down side – too many paths to follow can be just as bewildering as not having any idea where to start.

Having acknowledged the wide horizon, narrow your focus so that learning and appreciating technical and aesthetic qualities are easier to study. Do not be ashamed to make careful notes while you are looking and reading and try to keep a book for, or at least a page for, each subject or artist.

If you concentrate on one aspect at a time your notes will be coherent and much more useful than scattered phrases on a dozen different subjects. And in spite of the technological revolution, a notebook with pen and paper is still far more convenient for study afterwards than muttered recorded notes in a library which then have to be transcribed.

One additional way of learning about prints is to visit a printmaker or a studio. The art of printmaking is both a craft and an art; knowing more than you can learn from a book may help you to understand what elements in a finished print you most enjoy and what to look for when you start to collect. See WHERE TO GO, next.

Finally, a warning: collecting prints is a delightful pastime which may become a full-time occupation. There is so much to see, so many new images each time a gallery is discovered or an exhibition takes place that as a source of fun and enjoyment it cannot be bettered. Ever.

WHERE TO GO

Once you've enjoyed looking at prints and are interested in seeing more, there is an ever-growing number of places to visit and references to follow up. Start compiling a list and you will quickly accumulate enough information for a lifetime!

Museums

A good philosophy is always to start with the best. Most major museums of art have some prints on display, although you may have to ask at their information desk because prints are often hung together in the smaller galleries. This is sensible, as prints in general will be on a different scale from the customary collections of paintings, and many, especially etchings and engravings, need to be seen at eye level and often as close up as possible to appreciate their skill and detail.

A number of museums also have print collections stored in a library and these may have different opening hours from the main gallery. You may need to call in advance and, if it is a particularly old or valuable collection, provide a reference. For conservation purposes, white cotton gloves are often provided (or you may be asked to bring your own) to avoid any fingermarks which can damage the paper.

If their catalogue is online, then of course it is easy to find exactly what is in the collection before you visit. Time spent reading up on the artists or period that you are interested in will never be wasted.

Museums also have reference libraries to visit (be prepared to provide a reference) and will generally hold catalogues raisonnés on the major artists in their collection. These give as much information as is available, including some or all of the published prints. Most exciting is the fact that modern catalogues are well illustrated with detailed background and history plus a note of any known variations. This is invaluable for collectors and, of course, for dealers and auction houses as well.

For specific requests a Keeper in Britain or a Curator in the US is in charge of the print department, and their staff may provide an identification service if you have a print whose provenance is uncertain.

Museum people are far more approachable than visitors believe and, given notice by making an appointment, can be extraordinarily helpful to someone with a genuine interest in their subject.

Art fairs

This is a relatively new phenomenon since the enormous growth in affordable art. The larger cities will have regular art fairs, sometimes two or three times a year, where galleries and dealers come together to offer the visitor an amazing range. Some concentrate on paintings, others on works on paper which include prints, others on artist's books, but the best are obviously those specifically devoted to original prints and these are worth any effort to visit.

Opposite
An original lithograph by Ronald King bought at a Fine Book Fair where it was found illustrating a book of poetry.

Anthony Gross: KITE FLYING, *etching*

There will be a reasonable entrance fee and no compulsion to buy. Such a fair offers an exceptional chance to browse for hours, to talk to dealers and learn what is available, what the prices are, and what you might be interested in buying when that becomes possible. In short, a living museum of both past and present.

Most fairs also have a book stall with related titles and catalogues from exhibitions all over the world – these alone can occupy the browser for hours.

The range of the shows is remarkable. There will almost always be examples of the best-known printmakers and you may well find that a small but fine example of a Matisse or a Frank Stella is within your budget.

But go with an open mind, because you may also find an artist previously unknown to you whose work bowls you over, or a print in a medium you never really understood before. Some of the exhibitors no longer have retail premises and simply travel from fair to fair, so it's a chance to see examples which just aren't around in the ordinary market.

And you have the added comfort of knowing that the big fairs attract the best of the reputable dealers, so you can window-shop with every sense of security in what is being offered.

Galleries and dealers

Not enough people take advantage of commercial galleries in towns and cities. Whether or not you intend to buy, there will be very little pressure and generally a welcome on the sensible principle that the visitor today may be the buyer of tomorrow. If you are made to feel otherwise, then walk out.

The advantage is an ever-changing show, absolutely free. Young artists have their first chance to be seen, older artists reinforce their reputations (or not, as the case may be) and even the great names can be found – a show devoted entirely to Ben Nicolson brought together three or four dozen of his finest works.

Exhibitions are often full of surprises – an abstract artist turns to traditional etched scenes on holiday, a remote Inuit tribe shows a considerable sense of humour, an array of deckchairs shelters a flock of speeding rollerskaters…

Gallery staff also have access to stock not on show and many keep prints in stock, not necessarily on show; if you like an artist, but perhaps not that particular print, there may be other examples. Most important, ask about anything you are not sure of. The staff should be able to answer your queries. Put your name in the visitors' book and you may be invited to the private views!

Alistair Grant: SCHOOL AT ETAPLES
A traditional etching by a well-known abstract artist and teacher.

Auction houses

Another source of education and pleasure, the major auction houses are a remarkable resource for any art lover. You can visit on a viewing day and see at very close quarters many prints you could never afford and, indeed, if they are rare enough, may never see again.

Aside from the big names, Sotheby's, Christie's and Bonhams and their related companies, there are smaller auction houses which are sometimes even more accessible, but check with local dealers and galleries to make sure that their standards of research and information are reasonable.

Talk to the experts, ask about artists you are particularly interested in, even if there doesn't seem to be anything in the current sales – a lively-minded staff member will know about what happened last year and what might be coming up in the next. And all for free.

As if that were not enough, good auction houses have catalogues that contribute more than their weight in terms of history and knowledge. Today most are highly illustrated, with precise details of provenance, rarity, condition and any other information which might interest collectors.

Build a valuable library by looking up their back issues from previous sales; these are often available at the end of the season at a bargain price.

Buying and selling at auction is a different matter with some basic dos and don'ts. See more specific information on pp.100-102.

Bought at auction; a detail from a lithograph, COMPOSITION, *Albert Rafols Casamada, which still gives pleasure some thirty years later. Complete image p.155.*

Degree shows

Another new phenomenon, at least to the outsider, is the degree show of art schools, where the interested viewer has a chance to see exactly what the young are doing and where current trends might just be going in the next ten years.

Almost all fine art students do some print-making, in addition to those who have studied the medium more intensely with a practising artist.

It is not necessary to be a parent or a member of the university. Call up the schools early in the spring term and ask for the dates; degree shows are usually on only for a few days in late spring and early summer.

Take a note of the names whose work you think might be even more exciting in the future, and keep it safe. Spotting the stars of the future is an added bit of fun. The students are usually on hand to chat and exchanging names is one way of keeping in touch as they progress from young rebel to establishment figures.

And then...

Current information is always a problem as exhibitions may only last for a few weeks or even, as in degree shows, a few days. Check out which papers carry the most art show details, get in touch with professional organisations and join their mailing list, and read the local rag as well.

Open studios is a fast-growing concept with brochures and maps for visiting local artists in their homes and studios. Find out if there is a cooperative in your area.

COURTYARD, *screenprint*
A young student at Preston School of Art a few years ago. Will she be the next YBA?

Students are very happy to sell their work, too, so if there is no price on the label, ask! You may be a respected patron of the arts at relatively little expense.

CHOOSE FOR PLEASURE, BUY FOR INVESTMENT

Art has its fads and fashions. The big names of today might just be forgotten in forty or fifty years – these days perhaps in ten or twenty years! Those buying names that have withstood the time test have an advantage, of course, but equally it doesn't give the same thrill as when something bought for love and the pleasure of ownership has vastly increased in commercial value, too.

So do we have to choose between pleasure and investment? Yes, but per-haps as a matter of priority rather than pre-cluding either one. It is not unlike buying a home; you have to live in it, but it makes sense to think about what would happen if you have to sell!

We have talked to buyers, sellers, auction houses, dealers and investment counsel-lors. Their advice was surprisingly consistent and that is summed up here.

Investment first
If investment is the priority, then it must be taken as seriously as any financial venture. Decide how much you can spend a year and make sure you set this amount aside, whether you actually spend it or not. Go to an investment counsellor specialising in art and listen to what he or she suggests. Then go to an art dealer or if possible to one of the major auction houses who, after all, are anxious to make money, not only from what you buy but from who might buy your prints later. Listen well to what they suggest.

If their advice is the same, then it would be prudent to follow it. If not, then decide which you think is the more likely to prove

right, and follow your instincts. Keep focused – once you choose an artist, a period, a style, then keep within that area. Although individually it may not affect resale value, if you have to sell as a whole a coherent collection is always more attractive to buyers than a mish-mash of assorted images.

Stay in touch with your adviser – if he/she is well known in the field, then that will pay off when you sell as subsequent buyers will be more comfortable in bidding gen-erously, knowing their purchases had the approval of a recognised name.

Buy carefully, but buy often. You will make mistakes – even the most experienced dealer does – but you need those as well as success in order to learn.

Then set aside time to enjoy what you buy. Investment as a priority is one thing, but nothing is sadder than a collection of marvellous prints languishing unseen and unloved in a bank vault.

Art first
For those whose priority is enjoyment, there are surprising similarities in the advice from acknowledged experts.

So the first suggestion is exactly the same; decide what you can budget for every year and set that money aside.

Why is this so important? Because art will become part of your life and this brings the chance to purchase a print you never counted on finding, It's so much better if the funds are there!

It also helps the inexperienced collector to keep to a budget. It's all too easy to spend a little more each time and then find that you have overrun But if you have a separate sum set aside then bookkeeping is straightforward and expenditure easier to control.

Include expenses for framing and insurance in your budget – these are often forgotten. Both can mount up quietly, especially as you purchase more and more. Once you start you will be selling as well as buying; any kind of education may well change your likes and dislikes. The more you learn and the more you see, the more satisfying and well founded your new purchases will be.

Sally Scott: TAMARISK AND SHADOW, *stone lithograph A brilliant effect like this really deserves a fine but simple frame which might be expensive, but worth it.*

Buying

Few of us escape reports of sale prices at the major auction rooms – and with some reason: Sotheby's and Christie's have spearheaded the sales of all art work, trans-atlantic and trans-european, with offices in major cities all over the world. They offer not just a place to buy and sell, but seminars and lectures, courses on art history, expertise for television shows, magazines, articles, highly illustrated catalogues... the list grows every year.

For many buyers that is the first place to look, but there are many sources of fine prints – galleries and dealers, specialist magazines, the internet, and Art Fairs, all mentioned in WHERE TO GO, p.92. When seriously looking turns into seriously interested in buying, there are some pointers to remember.

Never pay more than you are prepared to see halved in value. The market fluctuates constantly and prints are no exception to the rules of the game. Even the seemingly inviolate post-Impressionists have days when there have been just too many available and it may come when you need to sell. Happily prints seldom reach the amazing sums brought by paintings, but small sums do add up.

No matter where the print is offered, take the same care in asking for written details and provenance, and checking that the print you are buying is the same as the one described, and in the same condition. Ask especially if there has been any restoration or repairs, and make sure your receipt specifies the answer.

Buying at auction

Check with auction houses for their next sale of prints. Ask for the catalogue in advance, so you can study what is being offered, and read the catalogue very thoroughly. What were once simple printed pamphlets are now, at the bigger auction houses, heavily illustrated, large books of reference which will be a valuable addition to your library, even if you never buy a thing.

While the wonderful array of information is compelling, resist it until you have read the serious business at the back. Major houses include everything, literally, that you need to know about buying, including what each of those little symbols means, what they guarantee (and what not) and, perhaps most needed, whether or not there is a Buyer's Premium, and if so, how much.

This is a fairly new "tax" on purchase, a percentage of the hammer price (the sum which is agreed at the striking of the hammer by the auctioneer). It is paid by the buyer and has to be added mentally when you are deciding whether or not to keep bidding, because it can add as much as almost 20% extra to the cost. Perhaps that is how we pay for all the extras now offered.

A great many details are set out very clearly in the two or three pages of small type, and depending on your particular interest it is worth reading carefully.

Once business terms are understood, go through the catalogue thoroughly and mark exactly which lots interest you.

Unless it is impossible, make time to go to one of the many viewing days. What are only words on paper become fascinating or disappointing reality. Take the catalogue with you and make notes all the time. Ask to see labels on the back if there is any doubt in your mind but, while some prints will be available in portfolios, most are usually framed and these will not be taken apart.

Talk to the porters – they are often art students hoping perhaps to be auctioneers themselves, or experienced staffers who have seen a great many prints in their time; both can be helpful and informative.

Make your decision and promise yourself to stick to the price you are happy to pay. The old scare stories of buying at the sale by scratching your nose or bidding against yourself are just that – stories. An auctioneer unsure of your bid will ask you to repeat it, or if you are bidding at all.

Don't count on seeing the prints just before the sale – often they are moved to behind the dais to help the staff bring them in and out during the sale.

But do arrive early for the best seats. It is surprising how often there is a change of mind at the last moment – perhaps one of the other prints looked too appealing or you see something in the catalogue about condition never noticed before.

It can be surprisingly helpful to write down the prices of all the lots, even if you are only bidding on one or two. As time goes by you may be interested in another artist or another print, and the records will be conveniently to hand. You can also arrange to have the sale prices sent on to you after the sale.

The worst enemy is your own enthusiasm as you see someone else walking off with what you want, and it becomes just one more little bid...and then another...and then another...

If you plan to pay with a cheque you will have to make arrangements beforehand or the print will not be released until the cheque is cleared. A simple form is all that is required a few days before.

It is assumed you will pick up the print either right after the sale or within a few days. Insurance will lapse after that and your lot may be removed to another, inconvenient site. If you do not live locally the auctioneer can tell you about delivery, but you will have to pay for it. Ask for an estimate beforehand.

If you cannot go to the sale yourself you can arrange for a bid by one of the staff. This is not so satisfying and it does mean you cannot change your mind and decide not to buy, but if you are likely to be carried away in the heat of the moment then it's a way of sticking to your budget. But do not give an absentee bid, then go to the sale anyway and bid against yourself.

If you are successful and come home with something you really wanted and didn't think you would be able to buy, what a pleasure it will be.

Selling

For all collectors there may come a time to sell. Then you may well hear a different story from insurance valuers and dealers. This should not be a surprise – your payment includes a profit for the seller, and now there must be enough to make another profit.

It is true that there can be a steady rise in the market which will ensure that you retrieve your investment and have enough profit to buy yet another print!

But you have to be prepared to hear that your particular artist is no longer in fashion or that prices have fallen. Once more your records will earn their keep. If you can quote chapter and verse about recent sales, or acquisition of the work by museums or well-known collectors, then you will receive a better result for your own bargaining. Having the details in writing will also guarantee that any agreement is based on clear facts.

Aside from auction houses and dealers, it might be well worth while trying other outlets. Talk to professional societies, visit art fairs, read specialist magazines and consider advertising on the internet, if you know how to manipulate the system. If not, make sure you find someone not involved in buying your offerings to help you navigate, because there is no doubt it is now a straightforward way of bringing together buyers and sellers. A private sale is the quickest and perhaps the most profitable, as there need be no profit for the dealer involved.

None the less, you may decide that an auction house offers the best choice.

Selling at auction

Timing is important. The major salerooms have a cut-off date for entries that is usually many months in advance.

If you find that this is not convenient, then explore the other avenues. If you can wait, sit down to weigh up the pros and cons before a decision. They include the support of a recognised company. Their experts will check your submission and if there is a problem you'll be told well in advance.

Ask for an estimate and a reserve. Without a reserve you may find your print goes for almost nothing on a bad day. If they offer no convincing explanation for a reserve you think is too low, wait for another time. In the event that no sale will be agreed, ask if there is a charge. This does happen and is not best practice.

Publicity and promotion will be part of the deal. Catalogue illustrations are valuable in drawing buyers, but a modest print may not bring enough to make it worth while. This can be negotiable. Ask about guarantees for the money to be paid before lots are let go. Make sure your own insurance is up to date and never rely on theirs, just in case.

Expect written notice of payments due. If this does not arrive then contact them at once.

Opposite
Marc Chagall: frontispiece for Redfern catalogue of 1966, with ten original lithographs. With the familiar Chagall images (clown, bouquet) the catalogue sold at US auction for well over $3,000.

CHECKLIST FOR BUYING –

ARTIST:	Confirm the name of the artist; there are whole families like the Pissaros who all made prints.
TITLE:	A title helps to identify a specific print, although some are untitled.
SIGNATURE:	Ask for the full name and initials, no matter what is actually on the print, and ask to note down exactly where the signature is and whether it is on the plate or stone (in which case it is printed with the rest of the image) or signed underneath, the best situation for authenticity. But be aware that some artists have signed reproductions, albeit usually of high quality, or even blank sheets, although this is very rare indeed.
NUMBER WITHIN A LIMITED EDITION:	The number on the print is the individual print number over the number of the published edition; but see Proofs.
SIZE OF IMAGE: SIZE OF SHEET:	Both sizes are important for subsequent identification. The date may or may not be on the print. If not, ask whether the date is known.
TECHNIQUE:	This may actually bring surprises as many modern prints are a strange combination of experimental and traditional techniques.
EDITION: DATE:	The total number including all proofs should be specified – so many APs, CPs, etc.
PRINTER:	A fine well-known printer or studio may add considerably to the value and will in any case be interesting to anyone researching modern prints.

PUBLISHER:
COPYRIGHT OWNER:

The publisher may also be the printer or a separate company, and the artist, the printer or the publisher may be the copyright owner. This is important if you subsequently want to loan or photograph the work. Although in the past it was customary for the artist to sell his work outright, now it is much more usual for the artist to retain copyright and simply to license the printer/publisher to make use of his image. The artist may occasionally insist on the right to borrow the work for exhibition, although this is usually limited to monotypes or monoprints rather than multiple editions.

REFERENCES:

Make a note if the print has been catalogued in a book or auction sale, or hung in an exhibition. It will make it much easier to sell on.

PRICE:

DATE OF PURCHASE:

Always get a receipt with all the details listed above, as you should for all works of art.

CHECKLIST FOR SELLING

All of the above facts should be given to the subsequent purchaser except the price you paid. It is also polite to add any known information which you have discovered yourself, such as additional references in articles or books, exhibitions where the print has been on loan, etc.

History is what makes up the print's provenance; keep a copy for your own records, even after the print has been sold.

FOR ALL THE INFORMATION ABOVE, MUCH MAY BE IN THE CATALOGUE OF AN AUCTION SALE BUT, IF NOT, ASK THE AUCTIONEER'S STAFF TO SUPPLY IT. IF THEY DO NOT KNOW, DO YOUR OWN RESEARCH.

PART THREE:

THE COLLECTOR AT HOME

RECORD-KEEPING

Why is it so important to record as much information as you can about every print you buy? The three prints on the right offer the best possible reason. Each was bought at a different time, each was made in a different era, and their intrinsic interest to the viewer may be wildly different, too. But without a few minutes spent to make a series of notes as soon as they come out of their wrappings, stories of their background, their provenance, and any contribution they may have made to the history of printmaking will be lost.

Start a file, either paper or electronic, for each print. Include all the details on the invoice, and if possible clip a photograph to the front. Keep correspondence with galleries or dealers, and a separate section for notes on where other prints hang, comments in papers, reviewer columns, and so on.

Include a sheet with the price on it and note down any prices which you see at auction or read about in the press of the same or similar prints, including previous prices (see VALUATION, p.111). Repeating a précis of the details along the top will keep you from having to look them up all the time to ensure that you are comparing like with like.

Add a file for "wish list" notes; a visit to a museum or a glimpse in a show might trigger an interest in other prints and new artists. Then you have a way of keeping track of someone you thought looked interesting, but was too expensive to buy at the time or too young to have enough work available for you to choose. Prices do go up and down, other examples might come on the market. Or, keep a travelling file, compact enough to go with you easily, with the minimum details and especially including future plans. Away on business or vacation, you might find something in a mixed portfolio of unframed prints, and at a reasonable price. These are often put together by local auctioneers from a number of sources, and the individual values are seldom recognised. Be careful of the condition, however, and convincing reproductions.

Include a list of the books you already have, and a wish-list for those you would like. It may sound too librarian-ish, but you don't need a catalogue – just a list of title and author will do for both cases. Art books are expensive and their titles often sound very similar. Bringing home an unwanted second copy of something you already have is a great disappointment.

Background notes useful for a file

Opposite, above left
William Strang: PORTRAIT OF RUDYARD KIPLING, *etching. Strang was so impressed with Kipling that he was happy to illustrate his* Thirty Short Stories *in 1901. A copy of the book might be a pleasant extra to have.*

Opposite, above right
Käthe Kollwitz: MOTHER AND CHILD, *1916, 2nd state, with signature added on stone in 1933-35. Her work was usually shadowed by the horrors of war and poverty in Berlin where her husband was a doctor, yet this lovely, tender study shuts that all away.*

Opposite, below
Paul Derbyshire: SUN CITY, *lithograph, a celebration of Hong Kong in 2001. A particular success at the artist's one-man show.*

CHECKLIST FOR INSURANCE

To provide the necessary essential back-up to any collection, no matter how modest, and to give added security in the event of damage or loss, these are recommendations from a major assessor and valuation company.

1. Keep files of all papers connected with your prints. Have one for each work if you can; it will make finding what is needed in the event of loss or damage that much easier. If the work is subsequently sold, keep records of your files for future reference.

2. Every print should be described as accurately as possible, including measurements of both the image and the actual paper. If signed, note how (initials, full name, etc.) the number, if relevant, and the date. ANY REPAIRS OR RESTORATION SHOULD BE NOTED AND INVOICES OR ADVICE MEMOS FROM RESTORERS/CONSERVATORS COPIED TO THE FILE.

3. Include both the date of purchase (and/or subsequent sale) and the price. A photograph is extremely useful. Note where in the house the print is hanging or stored – it is surprising what gets lost even in the smallest house.

4. Find out whatever possible about the artist, particularly less well-known names, and include notes in the individual file. Look out for reviews and notices of exhibitions, press cuttings, etc. Build a reference library and try to obtain any catalogue raisonné of artists in the collection – these are invaluable references.

5. Store or frame the prints according to best practice as described on pp.120-127.

6. Remember that items valued over a minimum amount usually have to be mentioned separately in insurance documents.

7. Check the value every few years. Artists have fashions and fads and what was bought for very little may now be worth much more – and vice versa, unfortunately. Every now and then make a habit of calling the leading auction houses which might have included the artist's similar prints in a recent sale. They often have information of prices in other countries as well.

8. Make friends, or at least the acquaintanceship, of dealers and auction house departments who sell artists you collect. They will tell you about news or events which may have a bearing on the value of what you own.

Valuation is essential in holding the best insurance for your prints, but it is not as cut and dried as some advisers would have you believe.

This has physical reasons – the kind of environment in the home – but also market judgements that a certain artist, and often a particular work of an artist, is more valuable than another.

Physical elements are under a certain amount of control by the owner. Local climate may make it very expensive to heat or cool an entire home, but damage can be limited by careful attention to advice for care and conservation. Any decent insurance company will want to assure themselves that storage, framing and hanging conditions are reasonable. They will also want to have some detail about the original condition of the work, which your notes should make clear, and copies of any documents that attest to restoration or repairs which might already have been done, or an estimate if you are planning work in the future.

In the case of serious problems, a special consultant in paper conservation should be on the list of your insurance company. This is a benefit of insuring with a company used to handling art.

A market valuation is a completely different matter and, unless you hold a famous collection whose sale could cause jitters in the art world, then any owner is to some extent at the mercy of fashion. And never underestimate how volatile that fashion can be. Today's market seldom waits for centuries to make up its mind about winners and losers. Ten to twenty years can change a valuation completely. This means that buying solely for long-term investment is a very chancy thing; none the less, knowing the current value of what you have is a sensible precaution.

Begin by deciding whether you want to know your prints' intrinsic value and therefore what kind of cover you need to replace them if you suffer loss or damage, or what you might achieve by selling them. These can be unexpectedly wide apart.

Generally, your home insurance should be based on current value, but if you plan on selling then you will need another valuation just before setting estimates and reserve prices. Auction houses, with their up-to-the-minute sales data, are probably the best place to go for that. See BUYING AND SELLING AT AUCTION.

To insure prints at home, value has to be based on the past rather than the future. A work of art is worth only what someone has been prepared to pay for it. This is where that boring record-keeping comes in handy. Every price you have noted of previous sales will help to establish a graph leading to the current value. Any fact of its being in a public or well-known private collection will add to its *gravitas*.

An insurer will look at the history, forecast a short way into the future, and should give you a reasonable quote. While no one wants to carry unnecessary expenses, when you have treasured and beautiful objects in your care then the extra effort to keep them safe is surely well worth while.

On the whole we are not talking about theft. Happily for the modest collector, most prints do not come into the category of truly major purchases and they are seldom the object of burglary or theft – too bulky and too little in return.

As far as all the art theft cases on record with Interpol are concerned, there has never been a case of ransom being demanded for a print, no matter how precious to the owner. So insuring them properly, in particular against accident, fires, or natural disasters like flooding, should not push you into stratospheric premiums.

However, if you want a valuation on a possible sale, quite separate factors come into play. And this is the kind of valuation that is likely to give an insurer nightmares.

To give you a sensible valuation, there are a number of factors to weigh up. And you

the owner can contribute to a meaningful decision, because the very variety of prints and printmakers who are not necessarily well known as painters or sculptors (although many have top reputations in both fields) makes it difficult for any one person to keep abreast of everything that happens in the salerooms – not to mention private sales or gallery prices.

But you have a much more limited interest in knowing what is happening only to those artists, and perhaps even only to those titles, which you own.

If your prints are all by internationally-known artists then, of course, a good valuer will have their last prices at his or her fingertips. It will be the work of a few hours checking on the latest prices on the internet for an estimated value to arrive at your door.

But most of us, even with a star or two on our walls, own prints which we bought for love of the medium, for delight in the artist's eye, or simply because we had to have that particular image.

Your records will be invaluable; a quick check yourself on what might be happening by a call to the gallery where you bought your print and a suggested total of today's market value should be fairly painless.

What a valuer can bring, though, especially from a good auction house, is an up-to-date knowledge about the rest of the market, even if it is in general terms. Local support for individuals or styles is a real fact; for example, garden or botanical

prints have certain appeal and should probably be in decorative sales, not in art sales, because so many people buy them for their flower power alone.

The Americans used to be far fonder of hard-edge abstract painting than Europeans, although that is changing rapidly, but the literary, portrait etchings of the 1930s would probably do better in Europe unless they are American authors or artists. And landscapes or village scenes find their most ardent supporters and best prices in regional sales.

Auction houses know this and will advise which of their many branches would do best with a particular print, a celebration of national and regional identity.

Some names are truly beyond frontiers, and recent sales have concluded that the famous American and English Pop artists of the 1950s, especially Andy Warhol, Richard Hamilton and Roy Lichtenstein, are still tops of the Pops. Their prices continue to climb and even press scares about unauthenticated copies do nothing to halt the levels at trend-setting sales.

For those who didn't climb on that particular bandwagon, Pop art has been generous anyway. The movement was intoxicated with all the new technology. Screen-printing in particular, so much more able to turn out large numbers of editions, and more comfortable for technicians to work with, was taken up with enthusiasm, so that there are more original prints from this period onwards than ever before – perhaps at less individual cost than for some of the finest etchings of the past,

The result of your discussions may raise the valuation of what you have bought not so very long ago. Take it with a certain amount of salt – no valuer will be ashamed, confronted with the wide margin between what was insured and what is now being suggested for expected sales – but it will help when the question of setting reserves comes up.

Once you have the valuation you may decide that it is time to sell one or more of your prints. Hopefully the reason will be the natural desire to expand your ideas and have something new for your enjoyment. And if the valuation has spurred you to action, perhaps there will be a chance to buy an additional print from the profit. In any case, it will be the right time to consider all the possibilities.

Research is never wasted

When interested in a particular style or movement, learn to look outside the obvious names. Many artists have built international reputations but may not be so well known in your region. Look through histories and magazines of the period to broaden your knowledge.
Andy Warhol has achieved the greatest recognition of all Pop artists, with his choice of soup cans and transformed portraits of icons such as Marilyn Monroe. But his quest for disseminating his work as far as possible is clear in this fridge magnet, screenprinted with his portrait and now a valuable auction prize for Pop collectors,
Telemaque, a Haitian artist who was in New York in the late 1950s before moving to Paris, produced some marvellous prints which celebrated the everyday object, in this case a saddle, and turned it into Pop art. Read up on any period to search for artists who will often turn into treasures once the bigger names have been exhausted by the market.

Right
Andy Warhol: ANDY, *screen-printed fridge magnet*

below
Hervé Telemaque: SADDLE, *lithograph*

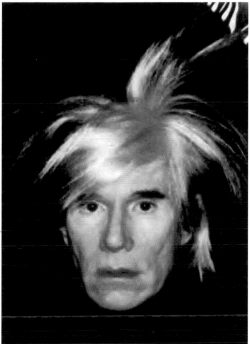

CARE AND CONSERVATION

Buying a print is only the first step in the process of acquiring a work of art and then slowly or quickly building a collection. Handling the print carefully, and making sure that the paper is and will remain in good condition is the second step, and then framing and hanging or storing it safely will ensure that whatever you buy remains a continuing source of pleasure and delight.

Paper

Because it is such an everyday part of our lives we forget how fragile paper is and how easily it can be damaged. Everybody has seen paperbacks only a few years old with yellowing pages and brittle margins. Yet a sheet of paper especially made for a historic facsimile in 1980 was guaranteed by the makers to last 500 years, given proper care. Somewhere in between are the papers traditionally used for print-making.

Early 18th and 19th century prints, even on thin, flimsy paper, can be surprisingly stable. Longer fibres from the cotton and linen textiles used in various amounts were less acidic than modern products. But manufacturing changed drastically in the 1840s as wood pulp became the major source for most factories, without realising or perhaps caring that their product would not be long-lasting or stable.

Even more, in the 1930s it was discovered that the addition of sulphuric acid to the mix broke down the fibres much more quickly. Again the long term results of this increased acidity were not considered, until in the 1950s acid-free papers and cards were developed to try to preserve historic archives and museum collections. Now available at every art-supply store, It is vital that all prints are mounted and backed in acid-free card, and that any tape or hinges used are also acid-free. Interleaving acid-free tissue is the final protection.

Although most modern prints of any artistic value are produced on various kinds of good acid-free papers, careful framing can help to avoid the continuing effects of the atmosphere in the home. Unlike museums, few of us are able to control our environment to any great extent. Humidity produces an additional problem – too dry and the paper becomes brittle, too damp and foxing (the term used for mould and mildew marking) appears all too quickly.

Although framed prints are less likely to be affected, dampness will eventually penetrate all defences. For this very practical reason, kitchens, bathrooms and certainly conservatories should not be hung with valuable prints, or even much-loved prints of no commercial worth.

If you own fine prints, never try to restore or repair damage; take them to an expert. You will probably make it worse.

Two common kinds of damage from lack of care.

Opposite, above
A 19th century print has not faded, but the paper has become badly creased.

Opposite, below
A modern print in brilliant orange was tacked up in a student's room for instant decoration, but is now a dirty ochre.

BATAILLE DU CAIRE, DITE DES PYRAMIDES, LIVRÉE LE 3 THERMIDOR AN 6. (21 JUILLET 1798.)

HANDLING

Good galleries will sell their prints already protected, either in an acid-free sleeve or properly mounted on acid-free board. It is when taking out the new acquisition to enjoy it more closely or buying from other sources that precautions should be followed.

Dust and pollution are everywhere, even in the best-kept home, and dust particles and fingermarks can penetrate paper surfaces to leave marks and begin the process of irreversible damage every time a print is lifted from its protective sleeve.

Margins are sometimes thought to be a carefree zone to keep fingers away from the body of the print, but dirt or damage on the margins may affect the value drastically and in any case will mar the appearance.

Contemporary artists, on the other hand, often abandon margins altogether and design their prints to cover the entire sheet, right to the edge. Modern framing takes advantage of this and new float-mounting systems show off every centimetre of the paper, including its edge. This makes it even more vital to learn to handle the print very carefully.

It may sound excessive, but a pair of well-washed cotton gloves should be kept to avoid any contamination. Even the cleanest hands have some oil on them, sometimes a residue of hand cream as well. Stains may not be visible until mould starts to grow and, while cleaning is possible under expert supervision, some stains are impossible to eradicate completely.

If the print will be moved around, during the choice of a hanging position or trying a new mount or moulding, taking off any hand jewellery – rings and watches – is a useful precaution. Always support a large print underneath to avoid any possibility of the paper creasing or buckling. Again, although these can be ironed out, it has to be done under professional supervision and it isn't always entirely successful.

If dealing with a portfolio or an inherited print, the first line of defence should be to ensure the old mounts are replaced; even if there are no obvious stains or foxing, it is far better to be safe and re-frame and re-mount everything.

More damage has been done by the careless use of ordinary sticky tape than almost any other material. It yellows and grows more and more obvious, the glue soaks in and discolours the paper underneath, and it is likely to tear the print when it is removed. You can buy acid-free tape for very little more.

If framing has to wait, it is worthwhile to put the print in an acid-free mount and backing board, then store in a portfolio.

If you like such unusual objects it is worth going to an Artists' Book Fair; many projects are sold in small editions of one to ten, easy to store and spectacular when opened out. Unfortunately, left on display they invite handling, and it isn't very hospitable to keep reminding your guests to be careful. Invest in a suitable cabinet or box and bring them out when you can all sit down and enjoy them, together and safely!

Special handling
Some prints are made as objects rather than standard art to hang on the walls, and they need extra care. A number of print publishers and artists collaborated on these multiples, not surprisingly usually in very small editions. Editions Alecto tried their hand at boxes, shapes, etc. and they make an intriguing collector's area. Their care and display need to be as carefully thought out as their purchase.

Right
Detail of a tray by Marion Glory; made of printed cast paper, it should be dusted lightly regularly. Not the most practical of drinks trays, perhaps, but a lovely thing to own.

Below
Miniature books should be kept in a cabinet, but they can be taken out and admired whenever necessary. These are two woodcuts by Julian Schwartz for EIGHT NUDES, produced by the Old Stile Press.

Storing safely

The portfolio for storage should be larger than any of the mounted prints. Check to make sure that it is acid-free; cheap card folders seldom are. A drawer in a large chest will do, if it is lined and cushioned with acid-free tissue. For anyone with a large collection of prints it is worthwhile investigating a plan chest. They are now made in reasonable sizes and an A3 or A2 chest will hold the majority of prints safely. For those with a liking for larger prints the architectural plan chests come into their own, but they are quite heavy and difficult to move around.

For truly valuable prints or permanent storage invest in special boxes which will keep humidity and temperature reasonably stable.

Archival or Solander boxes are available in a number of sizes and will mean that your prints (and photographs too) will remain in the best possible condition, for years if necessary.

For some oversize prints the only possible storage is in tubes. Although these are easy to come by, special acid-free ones are the only suitable ones and may have to be ordered from art shops.

A new product on the market is a collapsible tube with carrying handle, acid-free and suitable for larger or smaller prints by expanding or collapsing the lid. Prints should be sandwiched inside two large sheets of acid-free tissue, then rolled outside out, to avoid cracking the image by damaging the paper. BUT never leave prints in a tube for more than a short time.

A new problem is the number of prints which are being made in a very large size, sometimes with just two or more sheets of paper mounted together, but occasionally with extra large designs which are considerably vaster than any seen on the market for many years.

While this makes striking viewing, it also creates difficulties for the buyer who wants to display the work in an average home. Think before you buy. It is not just the expense of good framing but, if not on display, the problem of any kind of normal storage facility.

If under the bed is going to be the solution, then you will need to make a special storage pack with acid-free tissue paper as well as acid-free card, taped up with acid-free tape and protected from vacuum cleaners and curious cats. You have been warned.

Careless storage and good storage

Opposite
The owl sat unnoticed on a warm window sill until a strip of Scotch Tape melted into the paper.

Winifred Austen: MALLARD, colour aquatint. The precise opposite, this print with its lovely soft colouring, made over seventy years ago, has been properly cared for and kept in an acid-free box so that it looks as crisp and clean as it did when first printed in 1937.

FRAMING AND HANGING

It's a sobering thought that 65-70% of professional repairs needed on paper are caused by poor framing and hanging. Careful attention to both offers not only the pleasure of open display but the best possible protection.

The choice of framing devices is a very personal one, but there should be some considerations which override all questions of size, colour or style.

The diagrams (right) show how the various components are put together in a sandwich. They are separated in the drawings so you can see them more easily, but in the frame everything will be held together, the pins at the bottom holding the backboard tight in the moulding.

It is vital that the print should not press up against the glass. The pressure may actually lift some of the ink from the paper when the print is removed. The conventional window mount has a purpose which is not only aesthetic in setting off the image but provides a separating layer of air to give a little circulation and prevent mildew.

The mount should always be cut large enough to show the signature and the numbering along the bottom of the print. The print, the darker line in the diagrams, is always taped to the backing board behind it, not to the window mount.

Although the size is a matter of taste, most fine prints look best in a comfortably ample mount that keeps the frame as a protective edge rather than a feature which overwhelms the art. But it is absolutely vital

that the moulding is strong enough, no matter how elegantly thin, to hold the weight of glass securely.

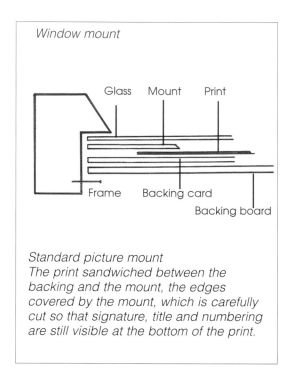

Window mount

Glass Mount Print

Frame Backing card Backing board

Standard picture mount
The print sandwiched between the backing and the mount, the edges covered by the mount, which is carefully cut so that signature, title and numbering are still visible at the bottom of the print.

With float frames, which show the edges of the print, there is no window mount and the required air space between print and glass has to be provided by a tiny fillet hidden behind the frame.

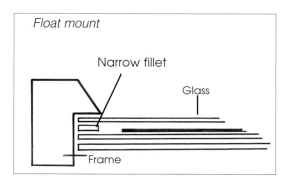

Float mount

Narrow fillet

Glass

Frame

122

When any frame is taped to the back it is far better to use old-fashioned gummed paper rather than plastic, as this also allows just a little air to circulate while keeping out dust and insects.

Multiple frames

With small engravings or etchings, or a related group of prints, it sometimes makes sense to frame them together. The mount will need to be specially cut. Try to arrange them first before going to the framer so that you are happy with the way they look.

Edge to edge prints can be attached to the backing board with invisible tape. As shown in the diagram opposite, a fillet will lift the glass above the prints.

Multiple frames
Some prints are very small, especially wood engravings which are made on the end grain of a block of wood. This makes it difficult to frame them so that they look attractive and are easily seen at close quarters. This set of three tiny wood engravings by Madeline Smith (the largest only 76mm or 3in wide) is a good example of how varied sizes can be united and will look much more attractive than if framed separately.

Framing materials

Frame-making was once a craft in its own right; cabinet makers of the 18th and 19th centuries specialised in elaborate carved frames, perhaps not particularly concerned with what went inside – mirror, oil painting, or embroidery.

Today in many cases we have galloped off in the other direction; some artists become committed to how their paintings look on the wall, incorporating frames into the finished work.

Prints are still largely left as they come off the press, although there are a few speculative artists working with cast and moulded papers which are complete in themselves.

But, generally, the print owner will need to think about what kind of frame suits each print. The choice of material nowadays is so wide that it becomes a personal statement of taste. There can be only a few basic suggestions.

Above all, pick a good framer. Make sure that he/she understands the need to ensure any material that touches the print is acid-free, and explain where the print will hang, if humidity is a problem; special fungicide-impregnated paper can be added which helps guard against mould.

Any of the traditional materials will do, but on the whole modern and contemporary prints look best in the simplest frames. Slim, black or painted or gilded wood or MDF moulding still looks elegant and discreet for etchings and engravings. In the '50s and '60s flat metal frames were a sign of the times and aluminium still looks smart and crisp on big, bold prints today. But be warned: when buying such a print already framed, always look carefully at the corners; many were cobbled together for economy without pinning and the glue has dried out, or the metal finish has chipped off.

Plastic clip frames are also popular for their pared-down minimalist look, but they offer no protection from dust and dirt creeping in around the edges, let the print touch the glass, and really should be avoided for any print worth keeping. They do very well for reproductions or inexpensive decorations.

There are some new ideas which deserve consideration; box frames, with the print float-mounted inside, look very attractive with any kind of art work. This can be especially useful if your print has some sort of relief or collage which needs extra breathing space under the glass.

It is best to re-mount older prints framed before the '50s completely because acid-free materials were then not available.

Framing is expensive. Good framing with the best materials is even more expensive. If the budget doesn't run to framing everything, choose an affordable number and keep any other valuable prints unframed, but properly protected in a portfolio or Solander box.

The statistic which began this section is worth repeating:

65-70% OF REPAIRS NEEDED ARE THE RESULT OF POOR FRAMING.

Right
Alfred Dunn: THREE BLACK IMAGES,
screenprint

Below
Margaret Knott: BRIXHAM, *monoprint*

Which way up? Do make sure that the framing of an abstract print is the right way up.

Although the purchaser will probably have seen the print hanging, framers occasionally ignore labels, even if they are on the back. Modern edge to edge prints may not have a signature on the bottom either. At the very least the wire or cord will have to be re-positioned or, at worst, the mount reversed as well.

Glass and alternatives

Glass is still the favourite glazing material but it has some disadvantages. Plain glass does attract condensation and there is no protection from light, while a large sheet of it can be difficult to hang without disturbing reflections.

Ordinary non-reflective glass has a habit of attracting moisture, too, but now there are museum-quality glasses with both UV filters and anti-glare surfaces. They are not cheap, but for the star of your portfolio of prints, which you want to look at every day, it is certainly worth consideration.

Perspex and Plexiglas are alternatives which are light, strong, and can be used in large sheets that can be held in by a light frame. But plastics tend to attract static and therefore dust, so keeping them clean is a chore – antistatic cloths need to be used regularly.

Another problem is that some kinds of chalky inks are affected by the static and may even lift from the paper. All in all, most conservationists suggest that glass is the safest material except for a very very large print where the size needed overwhelms all other considerations.

Opposite
Karel Appel: NOSTALGIE DE LA TROMPETTE DOUCE, *lithograph*

Brilliantly coloured prints are sometimes difficult to hang because the background may clash violently and seem to change the colour you see. If you have a large collection of prints it makes sense to be careful and keep to white or neutral walls.

Hanging

Once framed, there are two factors which should be considered before hanging any art on paper – environment and light.

General principles can be found in CARE AND CONSERVATION, p.116. Damp and humidity are the great enemies of paper, making it fragile, liable to tear, and letting moulds of all nasty kinds grow on the surface. If the room the print is to hang in is damp, then extra care needs to be taken in framing – tissues and absorbent granules are useful. At least keep the print away from resting directly on the wall with putty, or little buffers glued to the frame. And keep an eye out for any condensation which appears – it may be necessary to remove the frame and dry all the materials before re-hanging.

Light is the second enemy; it fades the colours and may damage the paper itself. No print should be kept in strong, direct sunlight, nor under a picture light attached to the frame, either. A spotlight on the ceiling or standing below on a table is the ideal source.

This brings in the problem of access – many prints have small details which cannot be appreciated if you have to stand more than a foot or two away. Furniture arrangement should take this into account. Bigger, bolder prints, of course, can be seen best from a reasonable distance.

Wherever you hang the picture, ensure that the wire or cord is strong enough to support the weight.

PART FOUR:
PRINTMAKING

TRADITIONAL PRINTMAKING: An introduction

Just as a glassmaker from the Roman Empire would be quite at home in a modern glasshouse, a medieval printer would easily understand the workings of a modern press, at least one used for relief printing from wood or linoleum blocks.

Woodblock printing was used for textiles for a thousand years or more and is still used where handwork is needed, or is cheaper than mechanical reproduction.

Although the Chinese were printing illustrated book blocks by the 9th century AD, the artist in the West was limited to painting on vellum and parchment. But once paper and printing presses were freely available in the 14th and 15th centuries, the miniaturists, who had created books of hours with their decorated initials, tiny landscapes and scenes of everyday life, must have inspired the first printings of biblical and secular texts.

With these came pictures for their often semi-literate readers; some illustrations were carved alongside the words. These are called block books and the first Chinese woodcut that we know is from just such a book. Other illustrations were separate blocks and could be used again and again in appropriate places.

It is often claimed that the first printed pages were playing cards, but it is hard to be precise about the dates. We do know that by the end of the 17th century printing had achieved a remarkable sophistication; printers and artists were beginning to move away from their religious base and produce all sorts of useful and educational images.

Subjects widened to include illustrations for herbals, bestiaries, medical treatises and other practical requirements.

With two artists who, almost alone, changed the Western world's perception, printmaking became an artist's medium. The works of Dürer and Rembrandt stand as the standards of skill and creativity, still beyond compare.

Once it was recognised as an art as well as a mechanical craft, printing took off on its first world expansion. Everything was produced in multiples, from scenes of current events for news-sheets to brooding ruins for tourists on the Grand Tour.

Along the way, entire rooms were decorated with black and white prints pasted on the walls; this popularity led to vulgarisation in the eyes of art collectors, and prints sold so cheaply were little valued, too popular to be good.

But, quietly, technology was making printmaking more reliable and more artistically viable, especially with the advent of lithography and then colour lithography.

Although in the 1870s it could be said that "the print is no longer considered suitable for the finest sensibility," only twenty years later a change of heart had taken place. Japanese prints showed that many of their finest artists were using the craft exclusively. Western artists had continued to make etchings, but now they tried their hands at woodcuts and lithography in all their responsive forms. Soon Paris was the centre for a new wave of excitement; the modern era of printmaking had begun.

Zao Wou-Ki. Lithograph, 1979. A popular and versatile artist working in a traditional medium to create something completely of its own time.

Estampería económica
PALUZIE

Guardia municipal montada. Andador. Guión. Escudo de la Congregación. A nadie perdona. Tu última hora se acerca.

Idea de la muerte. Agonía. Esta es tu morada. De la cuna al sepulcro.

He aquí nuestra librea. Fuí lo que eres y serás lo que soy. No te prometas larga vida. Morí pero no me marchité.

Tal es la corona de los triunfos. Sacerdote eterno, pero mortal. No hay razones con la muerte. Música de capilla. Ninguno reina sobre el sepulcro.

También la muerte me humilló. Huesos descarnados algún día revivirán. La dignidad no me exime de morir. La muerte no me respetó. Sacerdotes de

The boom in cheap paper led to posters and public announcements flooding into every area of life, even this gruesome reminder of the Auto da Fe processions of the Inquisition in Barcelona, with each group carrying symbols to warn other sinners of what might be in store.

132

Paper is possibly our most precious commodity – even well after the so-called paperless office, our consumption goes up and up, every year. Its history is far, far older than most people recognise, with the development in Ancient Egypt of a flexible support for writing, made from a local plant. Papyrus was available there as long ago as 3000 BC and, when the library at Alexandria burnt down c.50 BC, over five hundred thousand scrolls of papyrus were lost, taking with them the accumulated knowledge of the ancient world.

Parchment and vellum, the prepared skins of animals, had been known in Pergamum a hundred years before the fire, and gradually became the preferred surface of medieval clerks for durability and smoothness, a choice lasting well into the 15th century and later for important documents.

The Chinese tried experiments using plant materials and by around AD 150 they found the bark of the mulberry tree was the best staple. Its long fibres were later thickened with starch, pounded into flat sheets and then dried out in moulds made of silk and bamboo canes. Our earliest known print is Chinese, c.850.

Although the Chinese emperors tried to keep the process secret, by the end of the millennium Chinese papermakers were among those taken prisoners during Asian wars. With freedom and money, many were persuaded to start afresh in their new homes. A few millers reached Arabia and paper manufacturing was begun in Baghdad and Fez. There may well have been others – even Egypt gave up papyrus to make their own paper.

The invading Moors built the first European papermill near Valencia, in Spain, and, when they were thrown out in the great Reconquista, only the Moorish papermill workers were given leave to stay and continue their work.

During the next four centuries mills were built all over Europe, each generation developing new techniques. None the less the general principles remain: plant material is mixed with water into a pulp, cleaned and clarified, then drained and dried in frames.

The Japanese had stayed faithful to their bark content, and they still produce some of the finest paper for printmaking, as it is amazingly tough, soft and absorbent, and beautifully opaque. We know that Rembrandt bought a huge quantity of Japanese paper for himself and his pupils, the last cargo of paper imported into Antwerp before Japan closed its borders.

Gradually it was found that old linen scraps, cotton and other organic rags, even old ropes, made fine paper, still the favoured recipe for hand-made sheets.

With the discovery of cellulose from wood pulp, mass-produced papers for modern presses provide us with printed newspapers, magazines and so on. But artists have a world-wide resource in more varied papers, each with its own character, a fantastic range of types, colours, densities, and textures.

A printmaker's paradise.

Modern paper

Perhaps a little surprisingly, newsprint is in great demand in most printing studios. Cheap and cheerful, it will discolour almost at once, but it is invaluable for preliminary proofs and experimental ideas for new techniques, and even for wiping down the plates after inking.

Cartridge is a better grade and with a wide variety of surfaces it can serve for the next set of proofing. Most is also made from wood pulp and inevitably this will yellow and become brittle. There are fine cartridge papers which are entirely wood-free and the best quality is often used for long editions.

Mouldmade is a reasonable compromise between machine- and hand-made papers. The preparation is careful, the pulp can be of fine quality wood-free cotton or cotton rags, but the sheet itself is formed by a cylinder mould machine.

The choice of surface is basically the same as for watercolour paper: HP for Hot Pressed, NOT for Not Hot Pressed, and Rough. The best for printmaking is generally HP (the others will not pick up details in the image) and one that is not too highly sized, or the paper will not be absorbent enough to pick up the ink.

Mouldmade papers have an advantage over more expensive hand-made sheets because they are very consistent, a prime consideration when all copies of a long edition must be equally well printed. Fine mouldmade papers will usually be named directly on the details of the print – Arches and Velin from France, Bockingford and Waterford from Britain, and Fabriano, still working in Italy since 1276, and many, many more.

But for printmakers, especially those working in very small editions, the cream of papers come mainly from small specialist mills all over the world – hand made from beginning to end.

The process is almost the same as it has been for centuries, The sheets are made to order, rather than stocked in bulk; they are thicker than mouldmade papers, and cannot be quite as consistent. Some include effects like flower petals or grasses. Many are watermarked with their mill, the printer, or even, in the case of a special order for a particular edition, with the name of the artist and/or publisher. "Washi", the general term for Japanese papers, is still highly regarded for its soft waterleaf texture, glazed but not sized.

Many specialist mills will be happy to provide individual sizes and shapes, very large or very small, for unusual prints. There are mills also working with artists for projects with cast or moulded papers.

Colour, size or surface; the hundreds of fine papers made today will each bring their own contribution to the final print. Rembrandt used four different papers for one of his etchings, aware of how each changed the result. That same sensitivity is needed even more now when the choice is so great. The collector may not know exactly why an artist picked a particular paper, but an appreciation of its beauty and the quality it brings is possible for us all to learn.

Above
Detail showing marginal stains and creases which accumulate and will ruin the print's appearance and its value.

Below
Ursula Fookes: TOSSA, *woodcut printed on creamy paper which sets the entire colour scheme.*
There are many in-between tones in modern papers which will change dramatically the final effect of the print. Although some artists may not go to the length of Rembrandt in trying out various kinds, most are willing to experiment. Trevor Frankland's linocut on p.57 has also been printed on a chosen paper because of its texture and its creamy colour which gives even more depth to the black ink.

RELIEF PRINTING

Woodcut

The oldest form of printing, woodcuts are made from along the length of a block of wood, worked with knives and gouges.

The background is cut away until only the lines and shapes which make up the image are left. As in all direct printing, the image has to be designed in reverse to print correctly. It is difficult to cut across the grain and small details are seldom featured; the choice may then be wood engraving. The strength of the medium is the power of pure line and crisp edges. Where these are blurred it usually means a re-worked or repaired block.

Once cut, the surface is inked and the paper laid on top. Not much pressure is needed; a relief press (diagram on p.75), spoon, or a Japanese burnisher.

Many artists still prefer the contrast of black and white, or another single colour.

Colour within the image is provided by a number of methods; the simplest for the printer is to have a new block for every colour, but this means much extra cutting, generally used only for larger areas. Small areas, or sections of complex pattern, are coloured on the block by rolling and dabbing inks by hand. Japanese printers were masters of this, using tiny rollers and water-based inks instead of oil, with subtle results seldom equalled before or since.

From the early 1900s woodcuts were popular with Expressionists for powerful designs in simple line. More recently, the medium has had a revival as artists find hard shapes and lines in intricate combination, and now often with rich colour, enormously effective for modern images.

Below
Lyonel Feininger: FISHERMEN.
Opposite
Aline Feldman: CITY SCAPE *c.2002.*

Wood engraving

A name that seems to bring two kinds of print together, wood engraving is in fact not an intaglio process but a relief method, using the harder end-grain block of the wood. This can be cut with more delicate and precise tools than the knives and gouges used for woodcutting.

While woodcuts had become the happy choice of commercial printers for quick and crude illustrations, artists were looking for something more subtle and responsive.

An Englishman, Thomas Bewick (1753-1828), liked the sturdier and somehow more bucolic effect of the woodcut, but wanted more control and detail for delicate and idealised scenes of country life.

He made vast improvements to the techniques available, developing new and more precise carving tools. An imaginative change was to realise that scooping out white areas inside the design could be easier than carving around each black line.

A hundred years later this was developed into images made up entirely of white lines

– not surprisingly many seem to be night scenes, the figures coming forward out of black backgrounds.

Wood engraving fell into disrepute from the 1880s when, seized upon by reproduction houses for the mass market, etching and lithography became the more "artistic" methods.

In the 1920s and '30s, in contrast to the freer brushwork of modern painting, there was a strong revival of both woodcuts and wood engraving, especially among British artists re-discovering its unique qualities.

Wood engraving remains a popular art, constrained only by the relatively small sizes of the block, so sometimes a number are bound tightly together to make a larger image and then printed as if it were a single block, but if this is not well done then dividing lines will show up.

As it is harder to see such fine work, the design is often made first on transfer paper, pasted directly on to the block and then cut through. Colour can be added in the same way as for woodcuts, rolled on or painted after printing.

Avoid prints with broken edges or where continuous lines no longer print along their length. A few experimenters have tried printing engraved blocks in an intaglio press, but this can crack the wood.

The collector needs to look for softer images than those of the woodcut, more sinuous lines and fine craftsmanship. The prints are generally fairly small, and need careful framing to show of their best.

Opposite
Sister Margaret Tournour: LEOPARD

Right above and right below (detail)
John Nash: HELLEBORE
John Nash's wood engraving is typical of the finest Bewick tradition.

Below
Shiko Munakata: FLOWER HUNTING MURAL
(detail)
The Munakata woodcut shows the contrast between the two mediums; both are sinuous, flowing designs, but the Nash follows the line of the flower petal with ease, while the stiffer grain of the woodcut forces a harsher line, seen especially clearly in the horse's neck.

The shading in the Nash flower detail is also an indication of the fine work possible in wood engraving.

Linocut

A modern phenomenon that could only have come about after the development of linoleum cloth in the 19th century. For those who loved woodcuts, but found the material intractable and the size of the wooden blocks for engraving too small, the advent of linoleum was a revelation.

Linocuts are based on woodcutting – the oil is too soft for wood engraving – but it provides a wonderfully smooth surface, and responds to a lighter touch with knives and gouges. An additional trick is the use of small electric drills, similar to dentists' drills, that can cut neatly into the lino without leaving uneven edges.

Another major advantage is that linoleum comes in substantial rolls, so there is no limit to the size of the print. It can be printed by hand, so restriction of the bed of the press, too, is set aside. Most artists use a hardboard base with the lino tacked on top.

Some artists have developed quite exciting ways of dealing with what might be a bland effect, with less character than wood, by printing by hand and reprinting the same area to build up more interesting depths in the tones, either black or colour. Colour is inked on top or printed from a second and third block.

The texture of the lino does come through and sometimes creates blobs where the ink sticks to the surface, especially with pale colours. The collector should look for good, even colouring and good registration. The method works best with the same styles and subjects as woodcuts.

Opposite
Clifford Hatts: DUCKS, *linocut.*

Below
Enid Grierson: STILL LIFE WITH A VASE AND INSTRUMENTS, *linocut.*

INTAGLIO PRINTING

Intaglio is a generic term meaning below the surface. All intaglio methods (see pp.47-48 for text and diagram) are printed in the same fundamental way; the image is cut into the plate, the plate is inked, wiped, and the dampened paper is laid on top. When printing, the pressure will push the paper into the lines to draw up the ink, so there is always a slight embossing on the back.

The plate itself is traditionally copper, but zinc is also used as well as steel-facing, steel, brass, and even bronze. New materials include all kinds of rigid plastic sheets strong enough to take the weight of the press.

One of the points to look for in all intaglio printing is that the lines are clear and clean, that the pressure of the roller has not stretched the damp paper so much that it tears, and the plate mark is also clear but not looking fragile or torn. Careless inking is another common fault as lines stop halfway along their length or there are smudges where the plate has not been wiped enough. Of course sometimes this effect is intentional so it helps to see other work by the same artist.

The engraving or etching plate will gradually wear away, and prints at the end of a long run may not be nearly as good as the original forty or so, but the skill of a good printer can make it last for much longer.

If buying from the publisher or dealer, ask to see other copies and compare them, because the numbering on the print seldom reflects the printing order.

Engraving

The principle of engraving – that is, cutting an image *into* a surface – is thousands of years old; the first engravings printed on paper may date from c.1430.

Copper was the preferred plate for its workability; it can also be polished to give a clear background to incised lines. But it is not an easy craft to master; the burin is harder to use than the etching needle and there is no acid to bite into the metal. The tools must be pushed along steadily on an even keel, going deeper to print more heavily.

This skill tolled the death knell of the art, as gradually engraving in wood or metal became the province of reproduction printers, copying designs, albeit with magnificent craftsmanship, rather than making their own. There were revivals in the 19th and early 20th centuries, especially in England, but as colour printing grew more popular, engraving fell out of fashion again.

Even now, with the present revival of traditional methods, engraving suffers from the need to have very considerable skills in using gravers. It has been easier to confine engraving to a small area, perhaps in a multi-media print. This can be produced by the artist, but often today it is a technician who will work with the artist from a precise drawing.

None the less, there are artists who persist and thrive, working with a personal approach to the craft and its potential. Happily, too, some specialised aspects of metal engraving are also still with us in robust health: drypoint and mezzotint.

Above
Engraving and aquatint
Keith Armour: INDUSTRIAL
LANDSCAPE
The aquatint was used to
add a wonderful texture to
the hills/slag heaps in the
background.

Right
Wood engraving
Brian Rice: GAVRINIS
Making full use of the strong
linear imagery so typical of
modern wood engravings.

144

Mezzotint

Both of these techniques, mezzotint and drypoint, have lasted because they offer a unique factor which cannot be produced by any other printing technique.

Mezzotint creates a rich black of remarkable depth. Not an easy technique, it requires considerable skill on the part of the artist/printer to achieve that velvety look.

True, the very blackness of mezzotint has perhaps mitigated against its use in the modern multicoloured world, while etchings and aquatints have adapted to colour with ease.

None the less, there are artists who have promoted the knowledge and expertise which mezzotint demands, and certainly it has been a notable presence in mixed media prints, where its intense, dark power is set against other, lighter areas.

These supporters have also pioneered a modern adaptation of what was originally an 18th century experiment, adding individual colour plates, as many as three or four, to the print.

The slippling in the mezzotint which creates shadow and form can be even more noticeable in colour; the result is soft and mysterious – impossible to mistake for any other technique.

The collector of a mezzotint should look for that velvet deep quality of the black, without patches of grey.

Mezzotint
Most mezzotints are black and white, although in recent years the technique has been used in multi-media prints, where there may also be colour.

Opposite
Andrew Farron: METAL BOX

Right
VASE OF FLOWERS, *late 19th century*

Drypoint

This fascinating engraving technique has not only survived the change in fashion but has positively thrived in modern times.

A graving tool lifts up a metal line like a thin string which is then discarded, leaving a clean groove for the ink. A drypoint steel or diamond-tipped needle, in contrast, just scratches the surface, raising a tiny curled burr either side of the line.

Instead of being wiped clean as it would be in line engraving, the burr is left to pick up additional ink. This gives a soft, blurred line, with a dark centre from the scratch and slightly uneven, wispy tones either side. And if the needle is scratched more strongly and the burr is heavier, this will be so dark that the scratched line in the middle appears almost white by contrast.

We cannot be sure by whom or where drypoint was first used, but we do know that Rembrandt and his contemporaries worked with drypoint as a creative way of adding a darkened, softer area to a conventional etching.

This partnership of etching heightened with drypoint where emphasis or tone was needed has continued ever since and remains a favourite technique in modern printmaking wherever etching is still used.

There was a time from late in the 19th century when drypoint began to be used entirely on its own and that too continues. Modern printmakers welcome the knowledge that the drypoint burr does not last very long under the pressure of the intaglio press, so the present preoccupation with limited editions gives drypoint an added attraction. For the collector, as noted in the A-Z vocabulary, most drypoints are issued in small editions, unlikely to number more than 10-15.

But even then the prints may deteriorate in quality as the burr wears down. An intaglio press carries considerable pressure and, although it can be adjusted, it will simply squash the burr gradually and ruin its feathery appearance.

As numbering cannot be guaranteed as an accurate reflection of the order of coming off the press, if you are buying from the publisher or printer, look at as many copies as possible. Choose the print with the richest black around the lines.

If offered a single copy, then a decision has to be made about whether the print is a good example. A few visits to top dealers and museum collections should help the eye to know the best drypoint quality. Unless there is another strong reason for acquiring a particular print, a poor drypoint, perhaps at the end of the edition, will not do the technique or the skill of the artist full credit.

Opposite
Francis Dodd, RA: PORTRAIT OF CHARLES CUNDALL, *drypoint*

Etching

A very old technique that remains at the top of the list for linear printmaking. 1513 is the date of the earliest etching we know that is firmly dated and we really have little idea who did it or how it was discovered. But it must have been eagerly adapted as soon as possible by artists searching for some way of lessening the laborious task of engraving. Most of all, they wanted to find a way of drawing more freely than graving tools allowed, as if they were using a pen or pencil.

Etching was the answer. Both Dürer and Rembrandt proved that. Rembrandt's etchings are still the finest contribution to the world of printmaking that any one artist has made. He was not alone, of course; there were etchers all over Europe with varying styles and individual techniques, but all taking advantage of this new medium, more expressive than anything known in the past.

As always, the original print suffered as commercial printmaking took over the reproduction of watercolours and drawings with this new medium, but after photography became available the etching was revived and artists were encouraged from the end of the 19th century on to turn back to this original and expressive technique.

Above
J.M. Whistler: PUTNEY BRIDGE, *etching*

Opposite
David Suff: WATERLILIES, *etching and hand-painting. Handpainting on the plate adds colour but has to be renewed for each print, so there is inevitably some variation in the edition.*

Expressive is perhaps the defining word for etching as a medium, compared with engraving. The image is lightly drawn with a needle, using a metal plate covered with a layer of acid-resisting wax. The plate goes into an acid bath, which bites only into the metal where the scratches have exposed it. The rest of the plate is untouched.

All sorts of refinements have been tried. The original covering, called a ground, was hard so that the needle made crisp, clean lines in the metal. A soft covering, when tallow was added, can take the impression of a sketchy pencil drawing on paper, so that the image was even more spontaneous and delicate. It can also take impressions from objects and fabrics pressed into it, and this form of soft-ground etching has great appeal for artists today wanting additional patterns and textures.

The etching process has also been adapted to add texture and tone to this basically linear technique by the use of aquatint (see p.151). Colour can be added by hand on the plate, or with separate plates for each colour.

The collector should look for quality of line and printing. The etched line is fine and quite subtle, and the skill of the printer is paramount.

Too little ink and the line will suddenly stop printing where it should obviously continue; too much and there will be smears and blurs. Learn as much as you can about an artist you admire in order to recognise the sure hand of his or her work with the etching needle. It brings its own style, and many artists who are bold and brassy in lithograph or screenprint will still make the most delicate and delightful of etchings.

Aquatint

A process developed to add tone to linear etchings and engravings, aquatint created an entire new vocabulary for artists/print-makers. It began in France in 1768 and rapidly became a loyal partner. Most aquatints, even today, are a combination of etching and aquatint.

In fact, aquatint can be used on its own in images made up of blocks of tone, but this is not common and most aquatints have some sort of etching as well.

Aquatint was seized on quickly because of its ability to reproduce the effect of water-colour, then achieved its first wave of success in sketches and landscapes.

Mezzotint was already established, but, as can be seen on pp. 61 and 144-145, it works best in night scenes or indoor settings. Something else was needed and aquatint filled that need perfectly. It is the best, some feel the only, method in intaglio print-ing which can give an even tone without gradations. The name itself comes from its similarity to a fine watercolour wash.

The tone is created on the plate by a pow-dering of resin (see p.16). The plate is heated to fix the resin and, when put into the bath, the acid will bite around the granules to leave an even spattering of little rings with a light centre.

This is the identifying mark of an aquatint and can be seen easily under a glass.

Goya had been one of the greatest artists to exploit aquatint and etching, and with extraordinary effect. But after lithography was invented, aquatint fell into disuse, since it was far easier to paint on a wash than to go through the process of spat-tering, heating, biting, and so on.

In recent decades, as the craft of print-making has again become the province of the artist as well as the printer, aquatint has been revived along with etching, and at its best still provides remarkable subtlety in tone and colour. The collector should look for this and for even, smooth tones.

Sugar-lift/lift ground

The artist paints an image on the plate, using a special mix of sugar with a non-drying medium. A coat of varnish is laid overall before the plate is immersed in water. The sugar melts away and lifts the varnish to leave the image on the plate. From the collector's point of view the im-portant aspect to look for in a sugar-lift is the freedom of drawing in the image. It becomes even more like watercolour than ordinary aquatint.

Many mixed media prints today have areas of special technique like mezzotint, aquatint and sugar-lift. The description of the print should give all the methods used and, if you are not sure which is which, ask the seller. Consider visiting an art school or a fine art printer. Spending time learning to understand the processes will add to your appreciation.

Opposite
Margaret Knott: VASE OF TULIPS, *sugar-lift aquatint*

PLANOGRAPHIC PRINTING

Planography is the general term for printing manually from a flat surface, neither raised like a relief nor incised like an intaglio.

It usually refers to lithography and the "new" technique of screenprinting, but photo-screen printing was invented by Fox Talbot in the 1850s (although it was not generally adapted for, nor used by, artists until this past century and not substantially until the 1950s and later).

Lithography

The first principles of lithography were discovered by Aloys Senefelder in 1798, looking for a quick way to copy his pages and pages of music. His experiments were based on the natural antipathy of grease and water, as he found that paper laid over a wet stone with an image drawn or painted in greasy ink would pick up only the image.

Senefelder loved experimenting to see how far his invention would go and he tried many of the ideas still used for lithography today – tinted washes similar to watercolour washes; spattering drops with a toothbrush; grinding the stone to make it a little rougher like watercolour paper and painting with greasy chalk He even tried stone etching, which printed very fine lines. The transfer of images through a coated transfer paper was known by the 1820s and these techniques were eagerly adapted as usual by commercial printers for every possible use.

Artists had already made good use of Senefelder's ideas, but once colour lithography had been developed, using a stone for each colour, few artists could resist the temptation when asked to make posters or prints. Toulouse-Lautrec was only one of many, although the most famous. By the start of the new century, and with the encouragement of publishers in Paris and elsewhere, the popular lithographic print had arrived.

The fundamental technique is quite simple for the collector to appreciate, and the beauty of the method is how close it can come to the gestures and brushwork of painting. Unfortunately, it leaves no obvious mark to identify itself, being essentially flat. At first glance it can be quite difficult to tell a lithograph from a fine photographic reproduction on good paper. Look through a glass, and if you see the colour broken up into half-tone dots it is not an original lithograph. Carrying a glass with you is a good habit to form – there are opportunities everywhere these days.

There are also some pointers to distinguish a lithograph from a screenprint. Lithography can use water-diluted ink and, as it is washed on to the stone like watercolour, the result is more subtle than any other technique presently available.

As with all prints, look for good registration and clean printing. Lithographs can be printed in longer editions than most prints – 75, 100 or even more is not uncommon – and, because the stone can be touched up from time to time as necessary, the edition should not deteriorate.

Opposite
Graham Sutherland: COMPOSITION, *lithograph*

153

The popularity of lithography is enormous, and the range of prints equally bewildering. The huge variation of available styles and periods is just suggested here with four details.

For the collector, lithographic prints are perhaps the easiest to identify, as they have the painter's brushwork at their heart which is almost impossible to achieve with other printing methods.

But this also makes them liable to misrepresentation using a photographic reproduction. As it is a planographic method, there is no impression in the paper surface, so it makes sense to ask for a clear invoice stating exactly what you are buying (an

original lithograph) and with an adequate description of the image together with all the other details about paper, provenance, etc. An alternative source of comfort is to buy from a known dealer or auction house, with their catalogue information accompanying the print.

Below
Paul Derbyshire: CHURCHYARD, *lithograph*

Opposite
Albert Rafols Casamada: COMPOSITION, *lithograph*

Two prints which a lucky buyer found by chance in a folder of ten, sold at a suburban auction for less the the value of one.

Screenprinting/Silkscreen/Serigraph

All these terms are used more or less interchangeably. "Silkscreen" is the oldest, because the original screens were made of silk. Screenprinting became the commercial term for its use in packaging, advertising, etc. Finally the American art market decided to differentiate their work from the commercial form by inventing a new word, serigraph.

But it was an uphill battle, no matter what the name: "When an artist gives a design in some other medium to another artist/printer to make the screens for its reproduction in print form, it is not our practice to regard the result as original prints..." This rather pontifical statement trying to turn the tide was made in 1969. It was perhaps already too late to stop one of the major influences in mid-20th century art. Pop art and screenprinting were growing up together.

In 1957 Richard Hamilton and some of his friends in London sat down to make a list of

Right
Alexander Mackensie: ABSTRACT,
screenprinted on linen

One of the new advantages of screenprinting for the artist was its ability to print direct on to almost any surface. Textiles were particularly receptive, and this abstract was one of a set of tablemats produced in the 1950s as an experiment. Each mat in the set was designed by a different artist.

In fact it was not very successful in the long term as the print gradually was washed off, and more useful domestic textiles had to wait for screenprinting inks that were better quality and with greater ability to withstand the considerable wear and tear of normal family life.

what Pop art was all about:

Popular
Transient
Expendable
Low-cost
Mass-produced
Young
Witty
Sexy
Gimmicky
Glamorous

and, as a result of all of these, it was going to be Big Business!

None of the traditional media was going to be able to fulfil these criteria as well as the new approach to screenprinting, drawing on technical developments and the immediate access to popular culture in the form of advertising and comics.

There were always a few innovators ready to take on the establishment – with Hamilton's influence the Institute for Contemporary Art in London sponsored a portfolio printed by the Kelpra Studio, where Chris Prater fought to make screen-

printing a reputable medium for the serious artist. They sent some of the portfolio prints by Peter Blake, Allen Jones and Patrick Caulfield to the Paris Biennale in 1965. But, because the prints were not hand drawn, and, horror of horrors, photography was involved, the Kelpra prints were relegated to a separate part of the exhibition.

Yet screenprinting continued to develop as more and more artists were convinced that it could be a genuine art medium. Editions Alecto, founded in 1960, worked with Eduardo Paolozzi and many others to publish, and then to print, many series and portfolios as well as individual prints and multiples, usually screenprinted objects which were made in very limited editions.

One of the great joys of Pop art, and one which makes it particularly attractive to collectors, is that it is not a single manifesto but more of an attitude towards making art that finds varying expression in different countries and with a wide range of artists.

Although best known in the UK and the US, there were fine artists and new studios established in Germany and France all through the 1960s and, within the next decade, all over the world.

In the US, Pop artists like Warhol, Lichtenstein and Rosenquist began to use the technique with many of the new printers and publishers, such as Universal Limited Art Editions (ULAE), happily drawing their inspiration from mass-market ads and cultural icons. Most of the studios had been set up for lithography as well as

A NIGHT AT THE DOGS *Printmaking student, screenprint*

relief and intaglio printing, but gradually experienced commercial screenprinters realised they could adapt their medium for the serious art market. It was clear that screenprints were finally accepted as a vital medium, excelling in large prints with areas of strong, saturated colour. With the Andy Warhol shift into his Factory, screenprinting achieved all the promises of that defining list of 1957.

Pop art faded with the drop in the art market of the 1980s and quite a few studios had to close, too. Their work is now highly sought after as documenting a particular point in time when art burst out from its ivory tower into the real world.

But screenprinting has taken on a new lease of life with varied and exciting images, printing on a host of new supports – plastics, card, fabrics – whatever the artist and the printer could dream up together.

Over the next decades screenprinting took on many technological advances: stencils are now only one of the ways that the screen is configured; photography plays an important role, textures have been introduced, and screenprinting often forms part of a multi-media print.

IDENTIFYING SCREENPRINTS
Like lithography, screenprinting is a flat process and leaves no actual impression on the paper. Early screenprints were largely made with stencils, the shapes and forms often dependent on the skill of the stencil cutter.

The inks were much less translucent and thicker than lithographic inks, even from the beginning in strong saturated colours – sometimes even showing the mesh pattern of the screen at the edge of the print. Now modern inks are much thinner, but there are still a few pointers to note.

Only screenprinting can put colour over another colour, for complete coverage. A pure white often identifies a screenprint, although in the case of Grant's work opposite he used the paper's white colour instead of ink.

Smoothly blending colours, sometimes called rainbow effects, are characteristic. Fluorescent colours are found now only in screenprints, although computer printing is developing them.

Although most brushstrokes showing typical rough texture with flakes of pigment are lithographic, screenprinting ink can be diluted to a wash, as in the blue arch opposite. But the opaque coverage of the bright blue area could only be screenprint.

For the collector, there is so much commercial screenprinting that fine original prints depend greatly on the quality of the printer/studio. Research into this is never wasted.

Opposite
Alistair Grant: COMPOSITION IV, *screenprint, signed but not dated*
The blue has been used both on clear white paper and overlaid on the orange background.

Many of Grant's prints are not signed. As head of printmaking at the Royal College of Art, most of his last work was printed there.

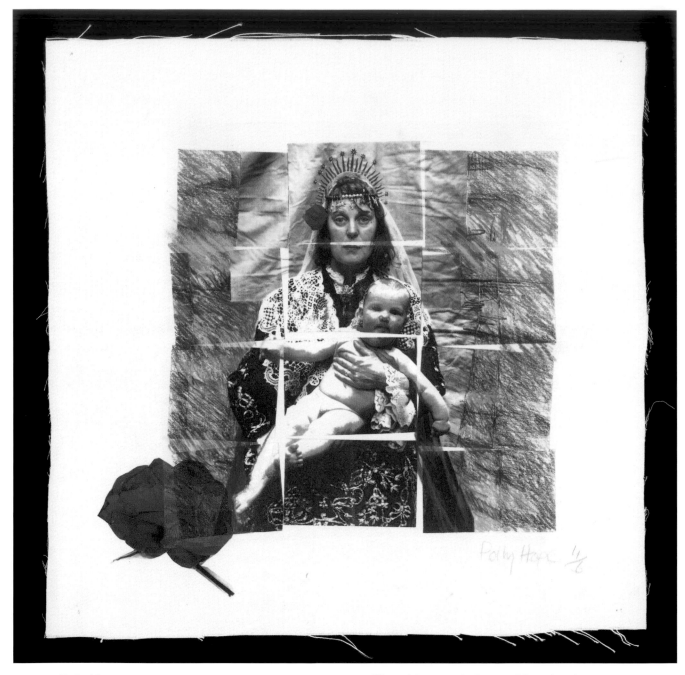

Polly Hope: MEXICAN MOTHER AND CHILD, *photograph enhanced with painting and then printed on linen. 1998.*

The white margin is considered as important as the print by the artist for the space it allows the image, the deliberately frayed edges on the cloth, and the rose superimposed on the edge.

Although regarded by many as the natural enemy of art, in fact photography was used by artists from the very moment of its invention and development during the 19th century.

Degas, for example, was excited by what photography could do, although he regarded it first as a tool for precise observation rather than as a separate medium.

At first photography was used to shorten or remove the need for hand transfer of images to plates, lithographic stones, etc. But these are technical adaptations rather than its use in the creation of images.

A few pioneering photographers could see the potential of the medium and wanted to be considered artists rather than mere craftsmen. Henry Peach Robinson was perhaps the best known, using up to nine negatives to produce large prints of typical Victorian genre scenes.

These were the first photomontages, but Peach discovered that as soon as his audience realised he had made up the scenes from separate photographs, he was treated as a fraud, trying to make photography the "art" it could never be.

Photography thrived much more successfully in the marketplace for colourful popular images, especially in newspapers, magazines and advertisements; quickly it became inextricably linked with commercial reproduction and advertising. Although a very few respected artists like John Piper were happy to try it out, it was not until after the fairly moribund state of traditional printmaking and the Pop revolution that followed in the 1950s that attitudes towards photography changed.

The early interest in popular culture and its photographed images was highlighted in a lecture by Eduardo Paolozzi at the Institute for Contemporary Art in 1952. From then on the Pop movement led the way towards an entirely new vision of printmaking which could use every kind of image as part of the creative process. Screenprinting provided a new and well-adapted technique, but photographic images as part of collages or projected on to lithographic plates were also used.

For the collector it is important to remember that photography, when used in the creative process, can be part of an original print but, when used as a purely reproductive process (i.e. copying an entire art work in another medium to make a poster or a print), it may not be accepted as an original and its value will be consequently downgraded. There is ongoing discussion about the precise place of photography and digital processes in assessing original prints, as technology changes and develops.

Other photographic processes are now being used by artists; photocopiers, fax machines, Xerox and Xerox transfers are all part of the experimental work being done today. In general, if the artist is the controlling element, it is considered an original print, provided it is properly recorded, personally signed and in a controlled limited edition.

Computers in printmaking

Computer manipulation

This is the lightest form of computer assisted printmaking, where the image is drawn, painted or photographed as usual in whatever way the artist prefers, but then transferred to a computer and manipulated, by using one of the many image programmes available. to achieve the desired result.

Colour may be added, or changed, lines increased in thickness, the whole or part of the whole flipped, enlarged or distorted, the texture altered – the list of manipulation which is possible is limited only by the quality and power of the individual software programme.

Although the critics may say that it is the machine which is creating the work, it is no less an original image than when the artist cuts out various materials to paste up a collage, or enlarges an original drawing by means of a grid.

Computer generation

This is sometimes even more controversial as the image is originally conceived and entirely created on the computer.

Most such programmes use a tablet to draw, so that the result may even have something of a freehand quality.

Artists using computer generation often use the process for a part of a multi-media print, where the image distortion can be tried, evaluated and changed in a few minutes instead of requiring wasted hours of experimentation.

Computer manipulation
Left, above
Margaret Knott: BEACH
An original watercolour sketch painted on a South Coast beach.

Left, below
Back in the studio, the artist felt the print would be more powerful if the image were condensed into a square format and this was done on the computer.
The remarkable quality can be seen in that none of the actual individual areas seems to have been distorted in any way.

Opposite
The original watercolour, LAKE COMO *(p.15) by Tom Robb was given a pastel chalk texture and enhanced colour in a series of computer manipulations.*

There are hundreds of commercial applications for such work, especially in repetitive designs such as textiles where the image can be so easily repeated without fault on to long stretches of fabric. If you look at some of the special effects in contemporary prints you will realise how wholeheartedly some artists have embraced the new medium.

There are many websites devoted to computer art, even a museum where you can see amazing combinations of traditional skills through the prism of the computer's potential.

For the collector, the vital factor is to understand what you are buying and to receive written assurances from the artist/studio about how the edition will be recorded and limited. As always, direct access to the artist or expert advice from a reputable dealer is the best guarantee.

Digital papers and inks

The result of the manipulation or generation on a computer may be stored as a file and then printed through a traditional medium. More commonly these days, the image can be printed out on a high quality printer, using the new digital coated papers and inks. In the past five years some of the leading manufacturers have experimented with papers and inks to provide a quality support to artists working at home without a print studio.

The paper itself is heavy and comes in a variety of traditional surfaces. This is then coated to absorb the new inks. These have been formulated to contain pure pigments rather than ink and have been tested to ensure their colour fastness for decades to come – some are assured for one hundred years at least. Details should be part of the description on the invoice or label.

PART FIVE:

SOURCES AND RESOURCES

A-Z SELECTED NAMES

This cannot be a comprehensive list as that would require a book in itself; almost all artists have produced some prints at one time or another. This must be a personal selection, arbitrarily chosen out of all the thousands of artists and printers/studios of the last hundred years who have made modern printmaking the force it is today.

The necessarily brief text concentrates on their contribution to printmaking, not on their work as painters or sculptors. Books and other reference material will lead to more substantial information.

We apologise to those who may not find their favourite artist or printmaker here, but hope there will be some names which will open up new interests.

Since this book is primarily for collectors, we have mentioned individual printers under their studios/companies, as these are the names that will be given in provenance and catalogue listings; such studios and presses or publishers provide an assurance of quality.

For more general information look in the bibliography; for individual subjects reference libraries are always a good start, as well as the professional organisations and current specialists and printer-publishers listed in FURTHER INFORMATION, p.184.

For specific names/topics, for those with access there will be a wide variety of internet listings.

A

ACKROYD, Norman, RA 1938-
A considerable contribution to the modern print has come from this English artist, involved especially with lonely landscapes in wild and empty majesty. As his hero, Turner, would have approved, Ackroyd takes his etching plates out into the open, washing on the acid and wiping it off with grass when required. It gives this part of his work an immediacy and spontaneity, balanced by more gentle and mysterious buildings and interiors.

ALBERS, Josef
Trained in the Bauhaus school, Albers emigrated to the US, taking with him a dedication to abstract screenprinting. Producing hundreds of prints, his most famous on the theme of a square within a square, he became the author of a highly influential book on colour and a teacher at Yale University.

ARCAY
Paris printer in the 1950s who worked with Vasarely and other abstract artists on the magazine *Art d'Aujourd'hui* and with Luitpold Domberger of Germany to develop the artist's use of screenprinting.

ATELIER 17
One of the least known in the outside world and yet one of the essential names in world printmaking, Stanley William Hayter was born into an artistic family, but soon realised he wanted to be a printmaker rather than an oil or watercolour painter. By 1927, established in Paris, he founded Atelier 17, his printmaking studio, which became the home and inspiration

for a world-wide coterie of fellow artists and students. Forced out by the war, he moved to New York in 1940 and reopened there, devising new colour techniques . For ten years, until he returned to Paris in 1950, he influenced printmakers and artists in their attitude to the printer as artist, inventor and collaborator, a full partner in the journey from creation to finished print. Along the way he produced some 300 prints of his own, mostly influenced by abstract surrealism, but his contribution to the craft lies far beyond his work.

AYRTON, Michael 1921-1975
A brilliant draughtsman, London-born Ayrton was also known as a painter, a sculptor, an illustrator and a novelist. But, for the last twenty years of his short life, he was preoccupied with the Greek myths of the Minotaur. and especially of Daedalus and Icarus. His many etchings explore every aspect of the story and its meaning.

B

BASELITZ, Georg 1938-
A German student during the rise of expressionist art, Baselitz began with etchings and woodcuts. These were quite figurative at first, but then in the late 1960s he began to turn his figures upside down to reflect social theories and concerns. His first one-man show was closed for public indecency, but his humour and skill won a steady audience. By the mid-1970s he was exploring different ideas in printmaking, using oversize sheets of linoleum and plywood, printing from them on the floor if necessary. Prints from then on would have much more impact in scale and colour, more in keeping with large scale painting

of the time. His neo-expressionist work is still based on figurative subjects.

BAWDEN, Edward RA 1903-1989
A remarkable range of graphics document the career of this extraordinary designer and teacher who produced an immense quantity of work throughout his life and for every imaginable application, including ceramics and wallpaper, as well as watercolours of extreme delicacy. His prints are particularly strong in linocuts and engravings.

BLAKE, Peter, 1932-
Anyone from the 1960s will remember Sgt Pepper's Lonely Hearts Club Band, the cover by Peter Blake, England's most famous Pop artist of the time. He contributed greatly to the Pop art screenprint explosion. More recent prints have been based on his paintings.

BRAQUE, Georges 1882-1963
No need to describe Braque's importance to painting, but his prints are equally fascinating, reflecting both his early Cubist compositions and the quiet simplicity of his later work. Braque worked a great deal with Crommelynck on etchings, exploring the way space in his compositions was always a prime factor. Crommelynck described him as a patient perfectionist; the serenity of his bird images in particular surely reflects this in his last, great series, *L'Ordre des Oiseaux*. Braque was particularly concerned there with delicate colours, achieving a remarkable degree of variety with deeply bitten textures, and washes with the delicacy of watercolours.

BRODSKY, Horace 1885-1969
Notable for being the first serious designer to work in linocuts, Brodsky remained a graphic designer rather than a painter, also producing some etchings.

C

CASAMADA, Albert Rafols 1923-
Spanish painter and printmaker of lovely semi-abstract and abstract prints with very free brushwork and light washes.

CHAGALL, Mark 1887-1985
Surely one of the most popular printmakers of all time. Chagall's Jewish Russian background combined with his Parisian life created an almost never-ending series of

Albert Rafols Casamada: APPLE ON A PLATE, *lithograph*

colourful prints in etchings, aquatints and lithographs. His first prints before he moved to America were all in black and white, sometimes lightly hand coloured, but once there he found new commissions and more time to work on colour.

Back in Paris, especially working with Mourlot in the 1950s and '60s, the brilliant, optimistic lithographs full of flowers and floating lovers poured out to a world-wide audience. But there is substance underneath the froth, perhaps only now beginning to be appreciated for the serious craftsmanship which informs them all.

CROMMELYNCK BROTHERS, Aldo and Piero
Master printers working in France. Aldo was apprenticed to Roger Lacourière in the late 1940s and gradually took over

contact with Braque and Picasso. They worked so well that when Picasso moved permanently to the south of France, Crommelynck followed and set up his own studio there in 1963, where he was responsible for about a thousand of Picasso's prints.

After Picasso's death, the studio moved back to Paris. Richard Hamilton began working with Crommelynck on his homage to the artist, *Picasso's Meninas*. Hamilton found his printer a true collaborator; "it's that subtlety of craftsmanship..." American Jim Dine was only one of the many other world-class artists who enjoyed this collaborative printmaking at its finest.

CURWEN PRESS
This English company grew from the 1920s under Harold Curwen, with book illustration and print editioning for almost every leading British artist. The Curwen Studio is still publishing.

D
DERBYSHIRE, Paul 1934-
Paul Derbyshire studied printmaking at the Royal College of Art and began a long history of inspiring generations of students at Liverpool where he established the Creative Printmaking Unit, running it until he retired a few years ago.

DINE, Jim 1935-
From Chicago, Dine went to New York early in his career and became part of the American development of performance and Pop art, along with Claes Oldenburg. A great many of his drawings and prints are based on personal possessions. The beautifully isolated draughtsmanship in the earlier

etchings – a heart, a twist of rope, a braid of hair – are eagerly sought by collectors and he has made screenprints. etchings and lithographs. Recently Dine has become fascinated by the natural marks on the etching plates, with much more heavily worked prints, but still always with an unmistakable personal vision. He had always been impatient with convention and his work with Crommelynck began to push the boundaries out – in 1985 one print was made from an off-set lithographic reproduction of one of his paintings, with an intaglio print on top. He also uses electric tools on many of his etchings, drypoints and aquatints.

DOMBERGER, Luitpold
Master screenprinter in Stuttgart who published artists such as Willi Baumeister. The company is still one of the major screenprinters and works with artists in Germany and beyond.

DOS SANTOS, Bartolomeu 1931-
A Portuguese artist of international stature and perhaps their leading printmaker, he studied and taught at the Slade School of Art in London for thirty-five years, as well as being a visiting teacher in Europe. Working in intaglio, especially in etching and aquatint, he also included photography in recent work.

E
ERNST, Max 1891-1976
In 1931 Ernst made nineteen small prints for an English translation by using a kind of photogram, drawings and collage on transparent paper exposed to light. John Banting in the UK used the same technique, except with iron salts on the paper, to produce his group of twelve blueprints.

Alistair Grant: COMPOSITION IX, *screenprint*

F

FLIGHT, Claude 1881-1955

The story of Flight's life is the story of the colour linocut. He taught, wrote and showed how powerful this humble material could be by example of his own work between 1919 and 1939. He also made a few woodcuts and wood engravings, but his heart remained faithful to the colour linocut for which he is best known.

G

GEAR, William 1915-1997

A Scottish abstract painter who lived in Paris at the end of the 1940s, Gear was to become one of the first to try screen-printing. Although primarily a painter, he continued to make these and lithographs which he printed and editioned himself.

GEMINI, G.E.L.

Kenneth Tyler is probably one of the best known American master printers in the art world. After working at Tamarind, Tyler moved to Los Angeles with the absolute conviction that if more artists were offered the finest collaborative effort in lithography, then the medium itself could be enhanced. Setting up Gemini Graphics Editions Limited, Tyler succeeded beyond his expectations, developing quite new machinery, if necessary, for every individual artist. See Tyler Graphics.

GRANT, Alistair 1925-1997

Born in London, Grant began as he was to go on, an abstract painter and printmaker with images firmly based on buildings and landscapes. His wonderfully subtle palette described the light, the atmosphere and the structures of town and country in shapes and colours. As a complete diversion, all his life he went on making traditional etchings of life around him in London and his beloved Etaples in France where he had a house. As head of printmaking at the Royal College of Art for twenty years, he was a defining influence on many of our best-known younger artists.

GROSS, Anthony 1905-1984

Gross, born in London, was a prodigy, producing over fifty prints before he was twenty-three. Later he was to repudiate his early work, preferring the etchings from 1929 onwards, heavily influenced by the linear paintings of Duty. He worked as a war artist and then returned to London to teach etching from 1948 to 1976 at the Central School and the Slade. By the time of his retrospective in 1968 there were already over two hundred etchings in the catalogue, and he continued working, displaying his own idiosyncratic and humorous eye for detail, almost until his death.

H

HAMANISHI, Katsunori 1949-2003

Hamanishi has a special place in the affections of printmakers. He is best known for his mezzotints, using this very difficult technique to great advantage, and including great depths of colour and tone remarkable in the medium. He is enormously popular in the United States where his work is in many major print collections and museums.

HERMES, Gertrude 1901-1983

One of the first women wood engravers to exhibit and teach. After the war years in Canada, Hermes taught at the Central

and Royal Academy schools in London. She illustrated many books and from the late '40s began to do colour wood engravings and linocuts as well.

HOCKNEY, David 1937-

A prodigy in every sense, Hockney is remarkable in having achieved world-wide renown at a very young age. While still a student in London he produced a major series of etchings with Editions Alecto, *A Rake's Progress*. Since then, firmly grounded in fine draughtsmanship and figurative subjects, his cool, open images have reached a very wide audience and his name is probably almost as well known as his hero, Picasso. One of Hockney's abiding delights has been the ability to reach out beyond the traditional art circles, and he has always been encouraged by printmaking and the use of the camera to fortify that aim.

Once he found his physical and spiritual home in California in the late '60s, Hockney began a life-long fascination with all the technical mastery of every possible printmaking process, including many which had never been heard of in the art world. Photography was a prime influence, but he has also used fax machines, photocopiers, and Xeroxes to create large-scale photo-montages. Hockney has also turned back to his preoccupation with literature, encouraged by R.J. Kitaj in his student days. He has produced monographs on art, on life and, in the past few years, on the invention of the *camera obscura*.

I

INDIANA, Robert 1928-

American hard-edge painter who became associated with the Pop art group with his iconic image in 1965, *Love*. This is the quintessential use of an advertising logo, and sums up the flower-power generation in just one word. It was so influential that there are few T-shirts or coffee-mugs in the average shop whose design cannot be traced back to Indiana's first painting. *Love* also became a limited edition print, a poster, a metal sculpture, and eventually a postage stamp. In 2004 a gallery magazine carried an ad for the Indiana print as a present for St Valentine's Day. The medium is truly the message.

J

JOHNS, Jasper 1930-

A remarkable artist who began his long career with images of targets in a kind of blend of Pop and abstract art, but he never lapsed entirely into abstract images. Most famous for his early subject matter, which included maps, targets and especially flags, the American flag, like Indiana's *Love*, seemed to sum up an entire era with its suggested ambiguity surrounding emotional subjects.

Johns worked with Ken Tyler at Gemini to produce lithographs with new effects, and Tyler invented machinery to suit each of his artists, for Johns working on a system to create a spectrum, or rainbow, effect on a very large surface. He also worked with Tatyana Grosman at Universal. Fellow artists were aware of how Johns, by working constantly in printmaking, was

172

Robert Indiana: LOVE, screenprint
Although he went on to make hundreds of
other prints, this one represents the artist as
none other – an icon of our time.

In line with knowing exactly what you are
buying, this genuine original screenprint is a
recently produced series in a different size
from the first 1968 print.

André Masson: CALIBAN, *lithograph*

legitimising a technique that had been out of fashion for some time. "John's prints... became like a marker in printmaking, an idea of what a print could be."

Later, Johns expanded his images to include references to American art (his image of the American flag in particular is known world-wide) and he made screen-prints, lithographs, etchings and reliefs, continuing to explore printmaking all the time. In 1990 a major show featured his work with four different studios, ULAE, Cemini, Simca and Crommclynck.

K

KELPRA STUDIO
The Kelpra Studio in London begun by Christopher and Rose Prater in 1957 was fighting what some considered a losing battle – they wanted to make screen-printing acceptable to the artists and the art collecting world.

L

LICHTENSTEIN, ROY 1923-1997
Born in New York, Lichtenstein followed the various popular themes of abstract Expressionism. It wasn't until a challenge from one of his children that he couldn't paint as well as the pages of a comic book that he produced his first successful and idiosyncratic images. To many people, these prints, which look like enlarged sections of some dotted, overblown comic, with their basic text in balloons, are Pop art. After exploring other styles, Lichtenstein returned to a simplified version of his Pop art imagery before his death.

M

MASSON, André 1896-1987
French-born Masson, a close friend of Joan Miró, joined the Surrealists but then during the 1930s returned to human emotions, heavily influenced by the death and destruction he saw in the Spanish Civil War. None the less he continued to be affected by the movement and most of his finest drypoints and etchings could be considered his own interpretation of Surrealist themes. He had moved to the United States in the 1940s with many other French artists.

MERTZ
A German magazine published from 1923-1932, Mertz was created by the Dada artist Kurt Schwitters to explore the casual haphazard art shared by some of his friends. They issued portfolios of prints by Jean Arp, Lissitsky and Schwitters himself.

MIRO, Joan 1893-1983
Trained in Barcelona, Miró was always influenced by his Catalan background and Gaudi's architecture. With his friends Masson and Breton his first lithographs and etchings already showed the soft, organic forms scattered over the paper which remained typical of his work throughout his long and productive life. He was loosely part of the Surrealist movement but always secure in developing his own vision. The first great series of prints from 1939, Barcelona Series, shows that his wonderful sense of humour was darkened considerably by the tragedies of war.

A visit to America in 1947 found him exploring the new intaglio techniques at Atelier 17, and his colour became more inventive and exciting. Back in France, Miró produced many different individual and series of prints, but almost all distinguished by his unique development of an alphabet of symbols, a kind of personal language that is always suggestive of something we recognise, often humorous, but never completely understood. His prints, as his paintings, remain universally popular and influential with artists as well as the general public.

MOORE, HENRY 1898-1986

Best known as England's world-renowned sculptor, Moore made a few prints before the war, but only began serious print-making from 1948 onwards working with lithographs produced on plastic at Cowell's. He worked with Mourlot in Paris on illustrations for André Gide, and then in the '60s with Stanley Jones at the Curwen lithographic studio and with Alistair Grant on etchings at the RCA.

MOURLOT FRERES, Atelier

The family began printing in Paris in1914, establishing Mourlot Frères in 1921, specialising in fine printing of posters and lithographs; collaborators included Vlaminck, Bonnard, Matisse, Dufy, Léger, Dubuffet, Miró, Picasso, etc. Fernand Mourlot joined the publisher Tériade to print for *Verve* magazine. He was also an editor and produced gallery catalogues and major books of lithographs, working often with Gallery Maeght. In 1964 the Smithsonian in Washington organised an exhibition of Mourlot lithographs; the Redfern Gallery 1967 catalogue in London contains original lithographs. Fernand published his autobiography and by the 1980s Mourlot Frères had passed the torch on to his grandson, who established his own lithographic studio, Franck Bordas, in Paris.

N

NASH, John 1893-1977

Brother of Paul Nash, he was encouraged by him to start drawing and painting, and he taught and wrote for many years in London. But his real success came as an engraver and illustrator, working on many, many books during the course of his life, and, particularly after he retired to country life in Essex, on wood engravings of botanical subjects.

NASH, Paul 1889-1946

A vital player on the British art scene, his experiences as a war artist from 1914 to 1918 mark almost all his strong, linear wood engravings. He also made a number of lithographs in colour during the 1920s and '30s with the Curwen Press. He became interested in photography both as a tool for an artist and for its own input into the creative process.

NEVINSON, Christopher 1889-1946

A war artist in the First World War, Nevinson began as a modern avant-garde artist but gradually grew more and more traditional in his style. His prints are mostly drypoints, lithographs, and a few etchings.

O

OMEGA WORKSHOPS

Started by Roger Fry, Omega was dedicated to the Morris ideal of handwork instead of machinery. They produced artists' books with woodcuts commissioned from Vanessa

Joan Miró: COMPOSITION, *lithograph*

John Piper: For Shakespeare's COME AWAY DEATH, *lithograph*

Bell, Mark Gertler, Roger Fry and others, leading to the Hogarth Press.

ONCHI, Koshiro 1891-1955
The first internationally-known artist to take the traditional Japanese print and bring it into the 20th century, Onchi was instrumental in reviving the classic woodblock medium as well as using every kind of new material for reliefs, including fish fins! He designed over 1,000 books in a lifetime of achievement. Onchi's enthusiasm and leadership created an entirely new modern print movement in Japan.

P

PAOLOZZI, Eduardo 1924-
A truly Renaissance modern man from Edinburgh, Paolozzi considered himself primarily a sculptor, but he made serious reputations in painting and ceramics as well. A major series of screenprints, *As Is When*, dating from the 1950s and printed by the Kelpra Studio, used his favourite scrapbook material and defined what could be called the pre-Pop age. Later he produced etchings and woodcuts – well over three hundred prints in all.

PASMORE, Victor 1908-1998
One of the first British artists to embrace abstract painting, Pasmore was a founder of the Euston School, but later became a fluent and prolific graphic artist, producing prints in almost all the mediums during his long and influential lifetime. Especially well known for a long series based on spiral forms.

PICASSO, Pablo 1881-1973
It is impossible to sum up Picasso's contribution to printmaking in a few words. Born in Spain, but living his entire adult life in France, his art was always firmly grounded in drawing, although he made few prints until the 1920s. A few early Cubist prints led to the illustrations of books published by Vollard and Skira. From 1931 to 1935 he produced the hundred etchings which make up the Vollard Suite on his ever-recurring theme of the Minotaur and the artist in his studio. With Lacourière's studio he discovered sugar-lift and also created his first colour prints in 1939. After the war he worked with Mourlot and explored the potential of lithography. This gave him a chance to record each stage in the production with trial proofs – one print had eighteen states as his mind shifted and changed.

Towards the end of his life, away from Paris and frustrated without instant communication with a studio, he began looking for other ways, and explored the linocut. There were also major groups of etchings and aquatints, again printed with the Crommelynck brothers who had set up their studio nearby.

Picasso's prints, almost two thousand in all, are less controversial than his paintings and have always been accessible and highly prized by the public as well as his fellow artists, the mark of perhaps the most creative artist of his time.

PIPER, John 1903-1992
Surprising to most who are familiar with his romantic ruins and churches, Piper began as an abstract artist, but by 1939 he had started painting the landscape watercolours associated with his name. He started printmaking by illustrating many

books using aquatint and lithographs. After the 1950s he produced individual lithographs on a larger scale, and finally some screenprints with the Kelpra studio. In the end his output was almost four hundred prints.

POWER, Cyril 1872-1951
Once seen, there is no mistaking a Power linocut. As a pupil of Claude Flight, he made the most of the medium. Always concerned with architecture and the new styles, he exhibited his prints from 1929-38 with Sybil Andrews and their work is immediately recognisable, icons of the '30s style.

R

RAVILIOUS, Eric 1903-1942
Best known for his wood engravings, Ravilious was taught by Paul Nash at the Royal College of Art in London, with his friend Edward Bawden. Killed during the war, Ravilious still left a substantial number of wood engravings, a few lithographs, a series from his work as a war artist on submarines, as well as hundreds of small designs for the Curwen Press.

RICE, Brian 1940-
A lifetime of printmaking devoted to teaching as well as producing paintings and prints. Rice taught at Brighton and in the 1960s-70s he produced many editions with Advanced Graphics for the American market. He was chairman of the Printmaker's Council 1974-77. In the vanguard of abstract art from the 1960s on, his recent work takes inspiration from archaeology, particularly prehistoric rock engravings. Recent relief prints and screenprints have reflected these themes.

RICHARDS, CERI 1903-1971
Primarily a passionate painter of colour and vivid flowing line, Richards did early black and white prints, but came into his own with lithographs inspired by the poetry of Dylan Thomas in the 1940s. After this he produced his best work with the Redfern Gallery and the Curwen Studio, and screenprints with the Kelpra Studio.

RILEY, Bridget 1931-
Born in London, Riley studied and worked there until at the end of the 1950s she began to develop her own version of Optical Art, at first mainly black and white lines and squares, and finally with colour. By the 1970s her style was fully established and instantly recognisable.

She is interested in how the eye will make the lines of colour strands shift, twist and move. Her work lends itself easily and immediately to printmaking, especially screenprints, which have brought a very iconic art into the homes of thousands of people.

ROTHENSTEIN, Michael 1908-1993
From a famous English family devoted to the arts, Rothenstein made his own impact by becoming a major influence in the teaching of printmaking. He had himself produced a vast number of prints in the 1950s and '60s.

After a time spent at Atelier 17 in Paris, he devoted most of his work to printmaking and writing. His three books on relief printing published in the 1960s and '70s are classics, but he continued to innovate and explore all the media throughout his life.

S

SHINSUI, Ito 1898-1972
As an apprentice in the traditional Japanese printing trade, Shinsui was recognised internationally as well as at home as an *Intangible Cultural Property*. He produced beautiful woodblocks of traditional subjects, allied to a modern simplicity.

SUTHERLAND, Graham 1903-1980
His first etchings as a London student were immensely successful, but later Sutherland changed his whole approach to art, becoming an international star and famous portrait painter. He turned away from etching and in the 1970s began a long series of distinctive colour lithographs, working with Mourlot in Paris.

T

TAMARIND LITHOGRAPHY WORKSHOP/ TAMARIND INSTITUTE
In 1960 June Wayne set up Tamarind in Los Angeles. Wayne was an artist who had looked in vain for the kind of collaborative printmaking in lithography that was found in Europe, and persuaded the Ford Foundation that such a business could provide not only a workshop for artists but a training ground for students who would go on to establish their own studios.

This turned out to be harder than it seemed, as art schools of the time in the US fostered the ideal of creative individualism – working within the confines of technology was considered openly commercial and lithography was tarred with the same brush.

But the dedication and drive of the founder drove Tamarind to continue, as the best artists from all over the United States were inveigled into coming to print at Tamarind, and incidentally to help the students learn the potential of the craft. In 1970 the educational focus was moved to Tamarind Institute in Albuquerque, within the University of New Mexico, and it continues to provide degrees and staff for the hundreds of new workshops, both commercial and non-profit, which grew out of the Tamarind experience. Tamarind (and June Wayne) continued as a lithographic print studio in Los Angeles. There are many critics who think that Wayne and Tatyana Grosman at Universal Limited Art Editions did more for contemporary printmaking in the United States than any individual artist.

TOULOUSE-LAUTREC, Henri de 1864-1901
No list could be complete without this extraordinary artist who almost created the medium of lithographic posters and of prints based on the theatres and cafés of Paris. He used the spare linear outlines of the Japanese woodblocks with the newer chalk and spatter techniques available with lithography to great effect.

TREVELYAN, Julian 1910-1988
One of the very sociable and artistic English Trevelyan family, he ran the usual gamut of Surrealism, "dream" paintings in Paris, where he worked at Atelier 17 under Stanley Hayter. Eventually he turned towards the grittier realism of contemporary art. After the war he taught at Chelsea and at the Royal College of Art where one of his many pupils was David Hockney. He utilised his teaching

experience to produce a standard book on etching techniques which is also a source of information about contemporary styles and techniques. His autobiography, *Indigo Days*, is a delightful period piece of the inter-war period in Paris and London. Trevelyan's second wife, Mary Fedden, herself a painter and printmaker, worked with him and witnessed a magic revival after the 1960s with literally hundreds of etchings.

TYLER GRAPHICS

Ken Tyler left Gemini in 1974 to set up again in upstate New York. The intention was to be nearer the home of many American artists and bring in new younger artists as well. Within a very few years Tyler Graphics took its place among the leading print shops in America and almost every major printmaker worked with him there. He continued to invent and innovate by working closely with the artists but now the emphasis seemed to follow new directions art was finding, moving from technology to craftsmanship of a very traditional kind. He promoted one-off prints, working with handmade and individually designed papers – flat, coloured, cast, and moulded. David Hockney summed up his special quality; "He's the chief collaborator, not just the publisher and not just the printer!" It was a sad day for many when the New York studio finally closed when Tyler retired.

A gift to the Walker Art Center in Minneapolis of the archive of all his work establishes almost on its own the history of printmaking in 20th century America.

U

UNIVERSAL LIMITED ART EDITIONS

This third of the trio of extraordinary American studios began almost by accident. Mr Grosman became ill and his wife decided to supplement their income by making silkscreen prints in their garage. But soon it was clear there was a new market for fine prints and, with a small lithographic press in the same garage, Tatyana Grosman offered printshop facilities to some of their friends.

Larry Rivers and Jasper Johns began to print with her, and gradually, with friends bringing in friends, ULAE began to produce regular editions, spurred on by Mrs Grosman's absolute conviction that only the best was good enough to represent their work. She also greatly encouraged the production of specially commissioned artists' books and Universal eventually added a publishing arm.

V

VERVE

A famous landmark of printmaking, *Verve* was published in Paris from 1939-1960, thirty-eight issues in all. It was an amazing attempt to provide illustrations and essays on every aspect of the visual arts, including original lithographs printed by Mourlot.

All its issues are eagerly sought by collectors. A book published in New York by Abrams documents its history and explores the aims and ideals of what one publisher called "the most beautiful magazine on earth."

W

WADSWORTH, Edward 1889-1949
A pioneering member of the Vorticist group, Wadsworth concentrated on wood-cuts during the period 1913-21, although he made a few lithographs, etchings and engravings. His work was documented by an exhibition at the Adelphi Gallery in 1919, particularly useful to the collector as he generally printed very few of each.

WARHOL, ANDY 1928?-1987
An idol of the Pop generation of artists, Warhol has come to embody almost all the themes which have created public recognition of popular art. He used advertising images of prosaic objects such as soup cans and cola bottles. He made huge silkscreens based on simplified blown-up portions of newsworthy people – his Marilyn Monroe and Chairman Mao prints are known all over the world.

He established a Warhol Factory (very much in the mould of Old Master studios) which depended on assistants and mass-production. To many he is the towering name of an era.

WHISTLER, James McNeill 1834-1903
A transition between the traditional engraving and etchings of the 19th century and the modern world, this American artist living in London and Paris left a major body of work which trans-formed printmaking. It was based on keen observation and subjective focus which could leave the background sketched in around a carefully delineated, usually topographical subject. He made hun-dreds of etchings, and began the artistic appreciation of lithography by developing tonal washes.

WINTERS, Terry 1949-
A well-known American painter and printmaker whose work encompasses every print technique, in a strong expressive style. Many American museums hold good collections of his work.

VERVE
One of FOUR PORTRAITS, *lithographs by Constantin Guys in the 5th edition of* Verve *magazine in 1939.*

For Further Information

To discover more about a particular artist, a group, a style, a form of printmaking, and what's available on the market or coming up for auction, almost all organisations today have a website; most artists can be found either under their own name, their gallery, or through professional guilds.

At the nearest art school, ask about local printmakers' groups. There are often city and regional organisations specifically for print-makers and collectors, far too many to list.

THE ROYAL SOCIETY OF PAINTER-PRINTMAKERS grew out of the etchers refused admission to the early Royal Academy of Arts. They have a Friend's membership with access to many of their resources, courses, events, and so on.
Bankside Gallery
www.banksidegallery.com
re@banksidegallery.com

THE PRINT COUNCIL OF AMERICA provides advice and suggested guidelines for collectors, as well as educational essays. The email address will vary as the officers of the Council change.
www.printcouncil.org
(present email) cohn@fas.harvard.edu

Magazines and newsletters online are useful; PRINTS-L is based on the exchange of information, with events, workshops, technical information, etc.
www.artmondo.net/printworks
or through a search engine for Prints-L.

ART ON PAPER is an international magazine incorporating the Print Collector's Newsletter. AOP includes notes of print workshops throughout the US, a calendar of exhibitions, galleries, etc.
info@artonpaper.com

ESTAMPE & AFFICHES was the 19th century French voice of printmaking; now it is

NOUVELLES DE L'ESTAMPE, published by the National Committee of French Engraving in Paris.
www.nouvelles-estampe.com
nouvelles-estampe@bnf.fr

GALLERIES AND DEALERS
Specialised dealers build up a reputation with attendance at fairs, the publication of monographs and themed catalogues. A major Original Print Fair catalogue will give you a good range of dealers in your region.

The main organisation is the INTERNATIONAL FINE PRINT DEALERS' ASSOCIATION. It has over 150 members all over the world, dedicated to promoting print collecting. Based in New York, IFPDA sponsors print fairs and has useful background on its web site.
www.printdealers.com
email: ifpda@printdealers.com

These are only a few of the dealers who specialise in prints; many issue substantial catalogues and books on the subject.

Alan Cristea Gallery, London
info@alancristea.com
Galerie André Candillier, Paris
candillier@magic.fr
Crown Point Press San Francisco
gallery@crownpoint.com
Curwen Gallery, London
gallery@curwengallery.com
Dolan/Maxwell, Philadelphia, USA
dolmax@mindspring.com
Equinox Gallery, Vancouver
equinoxgallery@telus.net
Falteri Grafica, Florence
falgraf@tin.it
The Fine Art Society, London
gc@faslondon.com
Flowers Graphics
graphics@flowerseast.com
Glasgow Print Studio, Glasgow
gallery@gpsart.co.uk

Graphic Studio, Dublin
gsg@aol.ie
Elizabeth Harvey-Lee, Oxfordshire
north.aston@btinternet.com
Hirschl & Adler, New York
JoeG@HirschlAndAdler.com
Inside Space, London
support@insidespace.com
Barbara Krakow Gallery, Boston
bkg@shore.net
Josef Lebovic Gallery, Sydney
josefl@ozemail.com.au
Marlborough Graphics,London/NY
graphics@marlboroughfineart.com
O'Hara Gallery New York
info@oharagallery.com
The Paragon Press, London
charles.booth-clibborn@paragonpress.co.uk
Pratt Contemporary Art, Kent, UK
pca@prattcontemporaryart.co.uk
Purdy Hicks Gallery, London
enquiries@purdyhicks.com
The Redfern Gallery, London
art@redfern-gallery.com
Scolar Fine Art, London
art@scolarfineart.com
Tamarind Institute, Albuquerque
tamarind@unm.edu
William Weston Gallery, London
ww@williamweston.co.uk
Caroline Wiseman
caroline@carolinewiseman.com
Gerhard Wurzer Gallery, Houston, Tx
gw@wurzergallery.com

MORE CONTEMPORARY PRINTERS/PUBLISHERS
In the past few decades some pioneering studios have closed, but others have entered the field. These three printer/publishers are only a small sample of the best.

ADVANCED GRAPHICS
Founded in 1967 by Chris Betambeau from the KELPRA STUDIO for commissioned screen-prints. From the 1980s AG published its own editions, adding a woodblock press in 1988.

The combination of the two is typical of AC's productions, Bob Saich joined in 1971 from Kelpra and now runs the studio. Gallery space was added for exhibitions with director Louise Peck.
gallery@advancedgraphics.co.uk

PARAGON PRESS
Charles Booth-Clibborn began in 1986, combining publishing and print-making. The Press is the studio, Booth-Clibborn Editions the publisher. They produce all the traditional intaglio techniques as well as some extraordinary multi-media prints. Their contribution is international in scope. See Email-dealer's list, left.

LANDFALL PRESS
In Chicago, Landfall Press has worked with artists and publishers for over thirty years. Originally a lithography studio, their output now includes some very innovative processes, with three-dimensional collages, artists' books, one edition with boxed records and another with a ceramic brick. Jack Lemon was the founder and remains the inspiration.
lfprints@aol.com

MUSEUM, AUCTION AND EXHIBITION CATALOGUES
One of the greatest sources of useful information are the well-researched and illustrated catalogues now accompanying almost any major sale or exhibition. Past catalogues are often sold at bargain prices.

Auction catalogues also provide an accurate picture of market movements; for all information on sales, prices, courses, etc.:

SOTHEBY'S
www.sothebys.com
CHRISTIE'S
www.christies.com
BONHAMS
www.bonhams.com
www.butterfields.com/areas/prints (US)

SELECTED BIBLIOGRAPHY

The first list concentrates on the period from 1880-1900 up to the present. Although many titles are out of print, they are usually available through dedicated bookshops and websites. Look for reprints and new editions. If the authors are printmakers, they often include a very good section on techniques as well; Rosemary Simmons and Sylvie Turner in particular provide thorough coverage about the craft.

A small sample of catalogues raisonnées for individual artists will offer some idea of how much you can learn from similar titles.

Books on printmaking are next, including those on printers and presses, which offer highly detailed examination of how prints are made, and some of the craftsmen and women who make them.

For all books, look for the title and author rather than the publisher – many were published in various editions, in different countries and with different dates.

GENERAL HISTORY AND INFORMATION

ALLEN, Bryan: *PRINT COLLECTING*, F Muller, New York, 1970

BOOTH-CLIBBORN: *CONTEMPORARY ART IN PRINT*, Paragon Press, London, 2001

BUSCHBAUM, Anne: *PRACTICAL GUIDE TO PRINT COLLECTING*, Van Nostrand Reinhold, New York, 1975

CALLOWAY, Stephen: *ENGLISH PRINTS FOR THE COLLECTOR*, Lutterworth, UK/Overlook, US, 1981

CAREY, Frances & GRIFFITHS, Antony: *AMERICAN PRINTS 1879-1979*, British Museum Press, London, 1980
MODERN SCANDINAVIAN PRINTS, British Museum Press, London, 1997
AVANT-GARDE BRITISH PRINTMAKING 1914-1960, British Museum Press, London, 1990

CASTLEMAN, Rita: *PRINTS OF THE 20TH CENTURY*, Thames & Hudson, London, 1988

DONSON, Theodore: *PRINTS AND THE PRINT MARKET; A HANDBOOK FOR COLLECTORS AND CONNOISSEURS*, Cowell, New York, 1977

GILMOUR, Pat: *MODERN PRINTS*, Studio Vista/Dutton, London, 1970
ARTISTS IN PRINT, BBC, 1981

GODFREY, Richard T: *PRINTMAKING IN BRITAIN*, Phaidon, UK, 1978

MILLER's COLLECTING PRINTS AND POSTERS, Reed, London, 1997

PRINTMAKING IN AMERICA: COLLABORATIVE PRINTS AND PRINTMAKING 1960-1990, Northwestern University/Abrams, New York, 1995

SACHS, Paul: *MODERN PRINTS AND DRAWINGS*, Knopf, New York, 1954

SALAMON, F: *A COLLECTOR'S GUIDE TO PRINTS AND PRINTMAKERS FROM DURER TO PICASSO*, Thames & Hudson, London, 1972

SIMMONS, Rosemary: *COLLECTING ORIGINAL PRINTS*; Studio Vista/Christie's, London, 1980
DICTIONARY OF PRINTMAKING TERMS, A&C Black, London, 2002

SMITH, Lawrence: *THE JAPANESE PRINT SINCE 1900*, British Museum Press, London, 1983

SPALDING, Frances: *20TH CENTURY PAINTERS AND SCULPTORS*, Antique Collectors' Club, UK, 1990

THE SYCAMORE COLLECTION; 20th CENTURY BRITISH PRINTS FROM A PRIVATE COLLECTION, Bolton Art Gallery, UK, 1988

THAMES & HUDSON: *DICTIONARY OF ART AND ARTISTS*, London, 1994

TURNER, Sylvie: *PRINT COLLECTING*, Lyons & Burford, New York, 1996

VICTORIA AND ALBERT MUSEUM: *FROM MANET TO HOCKNEY: MODERN ARTISTS' ILLUSTRATED BOOKS*, London, 1985

WEITMAN, Wendy: *POP IMPRESSIONS EUROPE/USA*, Museum of Modern Art/Abrams, New York, 1999

ZIGROSSER, Carol & Gaehde: *A GUIDE TO THE COLLECTING AND CARE OF ORIGINAL PRINTS*, Crown, New York, 1971

MAJOR ARTISTS

Anyone with a particular artist to research should look for a catalogue raisonné of their work, including their graphic work. With an artist as prolific as Picasso or Chagall, a general history often ignores the prints, so search for volumes on their lithographs, etchings, etc. Two fine examples are:

MARC CHAGALL: THE LITHOGRAPHS
The Sorlier Collection, Verlag Gert Hatje, 1998 Sorlier was Chagall's printer at Mourlot and produced individual catalogues raisonnés; this is over 1,000 illustrated lithographs in colour/ black and white. Includes interviews and overviews. Essential for collectors of Chagall.

BOUVET: *BONNARD: THE COMPLETE GRAPHIC WORKS*, Thames & Hudson, 1981
A revelation in that Bonnard's graphic work is entirely of a piece with his paintings and drawings. Completely illustrated.

Smaller volumes can be fascinating; this museum catalogue of a specialised exhibition had enlightening and thorough text. Look at the bookshop during exhibitions – they often have extra books on the subject besides the main catalogue.

MUNDY: *GEORGES BRAQUE, PRINTMAKER*, Tate Gallery, 1993

Tom Robb: CONSTELLATION, *lithograph*

PRINTMAKING AND PRINT STUDIOS

This can only be a very short list; there are many more written as monographs or group studies. These are some of the most interesting and instructive.

ALDO CROMMELYNCK, Waddington Graphics, London, 1986

GASCOIGNE, Bamber: *HOW TO IDENTIFY PRINTS; A COMPLETE GUIDE TO MANUAL AND MECHANICAL PROCESSES FROM WOODCUT TO INK JET*, Thames & Hudson, London, 1986

GILMOUR, Pat: *ARTISTS AT CURWEN*, Tate Gallery, London, 1977

HAYTER, S.W.: *NEW WAYS OF GRAVURE*, Routledge and Kegan Paul, UK, 1949

KING, Julia: *THE FLOWERING OF ART NOUVEAU GRAPHICS*, Trefoil, London, 1990

LAMBERT, Susan: *MATISSE LITHOGRAPHS*, Victoria and Albert Museum, London, 1972

NEWTON, Charles: *PHOTOGRAPHY IN PRINTMAKING*, V&A/Compton/Pitman, London, 1979

PIPES, Alan: *PRODUCTION FOR GRAPHIC DESIGNERS*, Laurence King, London, 1997

PORTZIO, Domenico ed; LITHOGRAPHY: *900 YEARS OF ART, HISTORY AND TECHNIQUE*, Abrams, New York, 1983

PRACTICAL PRINTMAKING, David & Charles, UK, 1983

PRESCOTT, Kenneth: *PRINTS AND POSTERS OF BEN SHAHN*, Dover, New York, 1982

ROSS, John and ROMANO, Clare: *THE COMPLETE SCREENPRINT AND LITHOGRAPH*, The Free Press, New York, 1974

ROTHENSTEIN, Michael: *LINOCUTS AND WOODCUTS*, Studio Books, UK, 1962

SIDEY, Tessa: *EDITIONS ALECTO: ORIGINAL GRAPHICS, MULTIPLE ORIGINALS 1960-1981*, Lund Humphries, UK, 2003

TATE GALLERY: *KELPRA STUDIO: THE ROSE AND CHRIS PRATER GIFT*, London, 1980

TREVELYN, Julian: *ETCHING; MODERN METHODS OF INTAGLIO PRINTMAKING*, London, 1963.

TRIVICK, Henry: *AUTOLITHOGRAPHY*, Faber & Faber, London, 1960

WALKER ART CENTER: *TYLER GRAPHICS; THE EXTENDED IMAGE*, Abbeville, New York, 1987

ACKNOWLEDGEMENTS

We should like to thank all the artists/ printmakers who have been so generous in donating their work and their time, particularly Brian Rice who gave so much support, the estate of Alistair Grant, Louise Peck at Advanced Graphics, and Paul Derbyshire, Clifford Hatts, Alan Taylor and Margaret Knott.

For their individual contribution, from the artist or their estates, we are grateful to Keith Armour, Winifred Austen, Irene Avaalaaqiaq, Michael Ayrton, Edward Bawden, Vincent Boczarski, Harry Brockway, A.R. Casamada, Tom Chadwick, Karl Demul, Francis Dodd, Alfred Dunn, Andrew Farron, Aline Feldman, Ursula Fookes, Trevor Frankland, Robert Gibbings, Marion Glory, Enid Grierson, Anthony Gross, Polly Hope, Albert Irvin, János Kass, Ronald King, Clare Leighton, Nicolas McDowell, Henry Moore, Shiko Munakata, John Nash, The Old Stile Press, Graham Ovenden, John Piper, Richard Robbins, Julian Schwartz, Sally Scott, David Suff, Graham Sutherland, Ruffino Tamayo, Sister Margaret Tournour, David Wurtzel, as well as those few artists and the students of printmaking we have been unable to trace.

Many collectors offered their cooperation gladly. We are especially grateful to Griselda Lewis, for herself and her late husband John, Beryl Phillips, for the estate of Lionel Phillips, and Barry and Kathy Holden.

Opposite
Far left
Richard Robbins: FIGURES ON THE BEACH,
etching and aquatint
Left
Richard Robbins: SEAGULLS IN THE WATER,
etching and aquatint

We also appreciate the timely help of Elizabeth Harvey-Lee. The Fine Art Society was generous with illustrations and contacts. The Redfern Gallery provided inspiration through decades of involvement in the original print market. We are grateful to Goldmark Art for their quick response and to Susan Harris of Sotheby's for her wise advice. Last, we should like to thank all at the Antique Collectors Club.

All these have offered invaluable resources and are responsible for much of the credit; all mistakes or omissions are ours.

Thanks too to DACS and their artists:

Karel Appel © Karel Appel Foundation/ DACS, London 2004; Georges Braque © ADAGP, Paris and DACS, London, 2004; Alexander Calder © ARS, NY and DACS, London, 2004; Jorge Camacho © ADAGP, Paris, and DACS, London, 2004; Marc Chagall © ADAGP, Paris, and DACS, London 2004; Lyonel Feininger © DACS 2004; Richard Hamilton © Richard Hamilton 2004. All Rights Reserved, DACS; Robert Indiana © ARS, New York and DACS, London 2004; Paul Jenkins © ADAGP, Paris and DACS, London 2004; Harald Kihle © DACS 2004 ; Kaethe Kollwitz © DACS, 2004; André Masson © ADAGP, Paris and DACS, London 2004; Henri Matisse © Succession H Matisse/DACS 2004; Joan Miró © Successio Miró, DACS 2004; Pablo Picasso © Succession Picasso/DACS 2004; Hervé Telemaque © ADAGP, Paris and DACS, London 2004; Victor Vasarely © ADAGP, Paris and DACS, London, 2004; Andy Warhol © The Andy Warhol Foundation for the Visual Arts, Inc/ARS, NY and DACS, London 2004; Zao Wou-Ki © ADAGP, Paris and DACS, London 2004.

Index

Page numbers in bold type refer to illustrations and captions